*I have always used drawing as a way of taking notes. When I was in the fifth grade, in a small-town Massachusetts school, instead of the prescribed tree with autumn leaves, I drew, with great conviction, a fancy woman sitting on a bar stool, with a highball in one hand and a cigarette in the other. I learned early that what you make isn't necessarily going to be praised.*

In a sweep of words, Fay Jones, whose work graces the cover of this book, creates an indelible portrait of the artist as a young girl. Her insight has the unself-consciousness of casual conversation and the surprise of a confidence offered unabashedly. This fresh immediacy punctuates each of the portraits in *50 Northwest Artists,* the second volume of a series on American painters and sculptors. Standing alone, many of the artists' comments, like Fay Jones's, do much to flesh out the artist, illuminate the individual artistic process, and generally demystify art for the reader. But it is the juxtaposition of the written word with illustrated artworks and the incisive images of the artists by nationally renowned photographer Marsha Burns that ensures this book will contribute to art history, not just to factual record. In *50 West Coast Artists,* the initial volume of the series, Henry Hopkins suggests a criterion for art history that seems as natural as Fay Jones's remembrance of being a ten-year-old artist in small-town America: "Art becomes

*Library of Congress Cataloging in Publication Data:*
Guenther, Bruce.
50 Northwest artists.
Includes index.
1. Artists–Northwestern States.
2. Art, Modern–20th century–Northwestern States.
I. Burns, Marsha.
II. Marquand, Ed. III. Title.
IV. Title: Fifty Northwest artists.
N6526.G83 1983 709'.2'2 83-10159
ISBN 0-87701-289-X (paper)
ISBN 0-87701-311-X (cloth)

*Acknowledgements:*
The collaborators for this book owe special gratitude to the following: David Barich, Jo-Anne Birnie-Danzker, Michael Burns, Michele Clise, Don Foster, Rachael Griffin, Linda Gunnarson, Joan Halpin, Jack Jensen, Martha Kingsbury, Rachel Lafo, William LeBlond, Kelly McCune, Tadao Ogura, Susan Pelzer, Laura Russo, Francine Seders, Larry Smith, and, especially, Leroy Soper.

*The following collectors, galleries, museums, artists, and photographers have graciously allowed the use of their work in this book:*

*Guy Anderson:* Courtesy of Mr. and Mrs. Raymond Cairncross.
*Jay Backstrand:* Courtesy of the artist. John Emmerling photo.
*Jeffrey Bishop:* Courtesy Linda Farris Gallery. Chris Eden photo.
*Joan Ross Bloedel:* Courtesy Foster/White Gallery. Robert Vinnedge photo.
*John Buck:* Courtesy Fuller Goldeen Gallery.
*Louis Bunce:* Courtesy The Fountain Gallery. Al Monner photo.
*Deborah Butterfield:* Courtesy of the artist and Zolla/Lieberman Gallery. Jamie Schlepp photo.
*Kenneth Callahan:* Courtesy Foster/White Gallery. Robert Vinnedge photo.
*Francis Celentano:* Courtesy of the Seattle Arts Commission and the artist. Michael Burns photo.
*Jack Chevalier:* Courtesy of Harold and Arlene Schnitzer. Cliff Edgington photo.
*C.T. Chew:* Courtesy of Dr. and Mrs. Martin Haykin.
*Judy Cooke:* Courtesy of Alice Plummer. Jim Lommasson photo.
*Dennis Evans:* Courtesy of the artist. Nancy Mee photo.
*Gaylen C. Hansen:* Courtesy of Mr. and Mrs. Jack Creighton. Ron Marsh photo.
*Randy Hayes:* Courtesy of Tod Hammond. Jim Ball photo.
*Paul Heald:* Courtesy of the artist and Traver Sutton Gallery. Jim Ball photo.

*Robert Helm:* Courtesy of Klaus and Gisela Groenke.
*William Hoppe:* Courtesy of Mr. and Mrs. Bagley Wright. Jim Ball photo.
*Paul Horiuchi:* Courtesy Woodside Braseth Gallery. David Bayles photo.
*William Ivey:* Courtesy of Robert M. Sarkis. David Bayles photo.
*Manuel Izquierdo:* Courtesy of the artist. Jim Lommasson photo.
*George Johanson:* Courtesy The Fountain Gallery. Cliff Edgington photo.
*Fay Jones:* Courtesy Francine Seders Gallery. Chris Eden photo.
*Diane Katsiaficas:* Courtesy Traver Sutton Gallery. Dick Busher photo.
*Mel Katz:* Courtesy The Fountain Gallery. Jim Lommasson photo.
*Andrew Keating:* Courtesy of Anne Gerber.
*Lee Kelly:* Courtesy The Fountain Gallery. Cliff Edgington photo.
*Edward Kienholz and Nancy Reddin Kienholz:* Courtesy The Louisiana Museum, Denmark.
*Sheila Klein:* Courtesy of the artist. Marsha Burns photo.
*Jacob Lawrence:* Commissioned for City of Seattle 1% for Art, Seattle City Light Collection. Steve Young photo.
*Norman Lundin:* Courtesy Francine Seders Gallery. Kathy Vargas photo.
*Robert Maki:* Courtesy State Office Building, Salem, Oregon.
*Sherry Markovitz:* Courtesy of the artist. Eduardo Calderon photo.
*Alden Mason:* Courtesy of the artist. Dirk Park photo.
*Peter Millett:* Courtesy Grapestake Gallery. Eduardo Calderon photo.

*Tom Morandi:* Courtesy of the artist. Donna Staley photo.
*Carl Morris:* Courtesy of the artist.
*Hilda Morris:* Courtesy of Reed College. Carl Morris photo.
*Frank Sumio Okada:* Courtesy Woodside Braseth Gallery. David Bayles photo.
*Lucinda Parker:* Courtesy of the artist. Cliff Edgington photo.
*Mary Ann Peters:* Courtesy of the Seattle Sheraton Hotel. Chris Eden photo.
*Jack Portland:* Courtesy of Jones, Bayley, and Grey. Robert Vinnedge photo.
*Michele Russo:* Courtesy The Fountain Gallery. Al Monner photo.
*Norie Sato:* Courtesy of the artist. Eduardo Calderon photo.
*Buster Simpson:* Courtesy of the artist. L.C. Simpson photo.
*Michael Spafford:* Courtesy of Mr. and Mrs. Raymond Cairncross. Paul Macapia photo.
*Peter Teneau:* Courtesy of Oregon Percent for Art Program.
*Margaret Tomkins:* Courtesy of the artist. Chris Eden photo.
*George Tsutakawa:* Courtesy Tsutsujigaoka Park, Sendai, Japan. Osamu Murai photo.
*Patti Warashina:* Courtesy of the artist. Roger Schreiber photo.

*Chronicle Books*
870 Market Street
San Francisco, California 94102

# Contents

CHRONICLE BOOKS • SAN FRANCISCO

# 50 Northwest Artists

A CRITICAL SELECTION OF PAINTERS AND SCULPTORS WORKING IN THE PACIFIC NORTHWEST
BY BRUCE GUENTHER • CURATOR OF CONTEMPORARY ART • SEATTLE ART MUSEUM
WITH PHOTOGRAPHS OF THE ARTISTS BY MARSHA BURNS
COMPILED BY ED MARQUAND

art history," Mr. Hopkins asserts, "through the published word accompanied by images." But finding a categorical shelter for the current series isn't really Hopkins's point; the dominance that New York has exerted on art publishing, critical writing, and the art market—to the exclusion of the rest of the country—is his concern. It is his conviction and my hope that this series will help to diminish that monopoly. Certainly the Northwest has been eclipsed. Aside from a handful of catalogues and books on such major historical figures as Mark Tobey, Morris Graves, and C.S. Price, the nationally distributed works that present an overview on Northwest artistic activity number exactly three: the National Collection of Fine Art's *Art of the Pacific Northwest* (1974), the Seattle Art Museum's *Northwest Traditions* (1978), and the University of Washington's Henry Art Gallery publication *The Washington Year: A Contemporary View, 1980–81* (1982). The first two books share a historical focus that excludes recent developments, and the latter deals only with Washington-based artists. *50 Northwest Artists*, a chronicle of contemporary painters and sculptors currently residing in Idaho, Montana, Oregon, and Washington, is, then, the fourth volume to document the region's art history. A

critical selection, the book by virtue of its scale can only serve as a primer of the region's strongest artists whose works deserve wide acclaim.

The fine arts community in the Northwest is a comparatively youthful one, having developed, in the main, during this century. Like much of the West, this region was traversed by artist-explorers during the first half of the nineteenth century; they were followed later by itinerant painter-signmakers and a few hardy photographers who made the gold and timber boom towns their homes. By the early 1900s, fledgling art communities took root in Portland and Seattle. Despite the frontier nature of the environment, these evolved into the richly diverse art scene of today.

With an enthusiasm possible only in a less cynical time, the early settlers brought the fine arts to the mud-clogged streets of the Northwest. The Portland Art Association and the Seattle Fine Arts Society (the precursor to the Seattle Art Museum) were incorporated by the turn of the century. Convinced of the civilizing power of classical art, these late Victorians established professional art schools whose faculty came from the East with a knowl-

edge of the latest European trends. By 1915 the principal art institutions of the Northwest—influential to this day—were launched: in 1909, the Portland Museum Art School, now Pacific College of Art, opened, and in 1914, in Seattle, the Cornish School of Applied Arts welcomed its first students. These institutions brought culture not only to the aspiring young artists of Portland and Seattle but also to several generations of socially prominent young women whose devotion to the arts has always been the backbone of patronage in those cities. The creation of these seminal art associations and schools in the early twentieth century was a direct response to the rawness of daily life.

The building of permanent facilities for the Portland Art Museum in 1931 and the Seattle Art Museum in 1933 heralded new opportunities for the visual arts and marked the closing of the pioneer era. The museums, through their changing exhibitions and small permanent collections, offered many Northwest artists their first exposure to important works of art. And from their first days, the Seattle Art Museum and the Portland Art Museum made a commitment to acquiring artworks produced by North-

west artists. Since the advent of commercial galleries was decades away, the museums' contribution was singular.

The establishment of the museums advanced Portland and Seattle as capitals of the Northwest art community. The vitality of the artistic life in those two cities was predicated on the presence of the museums and art schools. The isolation of the area east of the Cascade Mountains from Portland and Seattle had an inhibiting effect on the development of the arts. Outside the major cities, institutional support systems were slow-growing and the level of private patronage commensurately negligible. But the 1930s also witnessed the widespread growth of art departments in colleges and universities throughout the region and the emergence of the Works Progress Administration art projects. The boost was significant. Not only were there new economic underpinnings, but the artists who came on the wave of the WPA generated an excitement and a professionalism subject to no geographic boundaries. The odyssey of Carl and Hilda Morris—who traveled from Chicago to Spokane, Washington, with a WPA project, then on to Seattle, where they became friends with Mark Tobey, and finally to Portland—was typical of

9

the time. In fact, most of the artists of the Morrises' generation included in this book—Margaret Tomkins, Guy Anderson, and Louis Bunce, for instance—were fellow WPA travelers.

From the late 1930s on, arts activity in the Northwest has enjoyed a steady broadening of its base, even though it took until the late 1960s for private patronage and viable commercial galleries to develop in the distant corners of the region. This time span might seem puzzlingly long, but it was somehow necessary to the evolution of a middle class sufficiently large and affluent to produce a market for original artworks. In the Northwest, critical recognition has had little to do with economic success. Even today, most of the senior artists live modestly, earning enough money from sales and perhaps an occasional teaching stint to keep working and to make periodic forays to the East Coast and Europe. Recently, the innovative Percent for Art legislation and Art in Public Places programs in Washington state have greatly altered the economic possibilities. The spread of such programs throughout the Northwest has meant that original, contemporary art now reaches even the smallest hamlet within participating states and that more artists than ever are able to sustain themselves through their work. A concentration of public art monies from city, county, and state sources has made Seattle the center of contemporary art activity in the Northwest.

Portland painter Louis Bunce has said that in the Northwest "[Nature] flows up the streets." Unlike the more populated areas of the country, it is impossible, in the Northwest, not to be aware of nature even in the most urban locations, and this obviously has a significant bearing on the character of the arts. From the lushly forested and populous coastal strip to the vast wind-shaped, high plateaus of the interior, nature is staggeringly beautiful. No artist could remain immune to its grandeur. While one can only speculate about specific influences, there is no question that natural phenomena, in some form, are evident in the most abstract works. Artists as diverse as William Ivey, Paul Heald, and Jack Portland have drawn inspiration from the effects of the moist coastal light. In fact, the continuing viability of the landscape tradition in painting is rooted in the omnipresence of nature. This tradition has moved with the times, absorbing the successive modernist idioms that prospered, from cubism to

abstract expressionism to neo-expressionism. Each generation of artists has found a fresh motivation and vision in the varied landscape of the Northwest.

As is clear from even a casual perusal of the artists' work in this volume, the response to nature has not been concerned with explicit phenomena but, rather, with atmosphere, that intangible quality of light and color that infuses an artwork with a special sense of place. The work of William Ivey is an excellent example of this sensibility. The intensity of color and the quality of light within his abstract canvases call to mind sunshine cutting through moisture-laden air to illuminate a landscape against the receding gray.

The geographical distance of the Northwest from the major art centers of the East Coast is both a blessing and a drawback to the artists who choose to work here. Away from New York there is an absence of pressure to conform to the correct political or stylistic position or to be marketable according to the latest fashion. In the Northwest, artists have a greater opportunity to find themselves within the modernist tradition and to assimilate meaningful influences without succumbing to the dictates of

the international art press. Such an atmosphere of freedom of choice and intellectual diversity is rare in a label-conscious society, with a press and marketplace that crave novelty; however, it is not without its potential costs to the artists. The lack of stringent critical commentary outside New York means that artists without a sense of rigorous discipline run the very real danger of complacency and eventual irrelevance. Additionally, the Northwest lacks the large, inclusive collections of historical artworks that traditionally have formed a vital part of the foundation of an artist's training. Given this limitation, artists have relied on traveling exhibitions, publications, and sojourns outside the area to provide this aspect of their education. The isolation of the Northwest has helped to ensure that every major exhibition, visiting artist, and publication comes under intense scrutiny and evaluation within the artists' community in a manner that is unusual in locations with more plentiful resources.

In choosing the artists for presentation in this volume, I have sought to put forward the best painters and sculptors at work in the Northwest today. The selection includes senior artists who continue to make exciting new work, mid-career artists in the easy stride of mature

production, and young artists whose performances to date promise influential careers. The work of these Northwest residents has attracted national—and, in some cases, international—attention and exhibits an innovative vigor. The individual integrity of vision and continuity of effort creates an art that does not reveal itself immediately but persists in stimulating and engaging the viewer. Respectful of the possibilities of their chosen media, the artists inventively use materials and imagery to extend our understanding of visual experience with a lively energy. Each has, I think, chosen to create an art that draws its intrinsic meaning from human experience, that is respectful of itself while acknowledging its historical antecedents, and that establishes an individual sensibility —a presence.

The contributions of these artists are immensely important to the health and national visibility of the Northwest art community. No history of the art of this region would be complete without mention of these women and men and their work. Modern and contemporary art require an active dialogue between viewer and artwork that encompasses the implicit intention and artistic process if it is to stretch beyond the artwork's silent, obdurate presence. It is my hope that this introductory volume will provoke the reader to begin just such a dialogue and, perhaps, to experience the work firsthand. As Joshua Taylor, the late, distinguished Director of the National Museum of American Art, said of Northwest art, "[There is] a special flavor to the art produced in the region—it is to be found in the looking, not in the talking about."

My desire to contribute to this project included my wish for the artists to have dignified photographic representations of themselves for reproduction with their work. Part of this desire was to provide, for historical purposes, a clear visual record in a photographic likeness, with little attempt to interpret or to reveal the spirit or essence of each subject. Thus my interest was not consistent with the traditional notion of portraiture. I trust each artist's work to provide whatever might be essential to an understanding of that artist.

These intentions greatly dictated the formal character of the photographs. The neutral environment and artificial light source were consistent, though I traveled and photographed in different places.

I wish to thank the artists for their complete cooperation with my approach. I am pleased to have been involved in a project of such value.

*Marsha Burns*

# 50 Northwest Artists

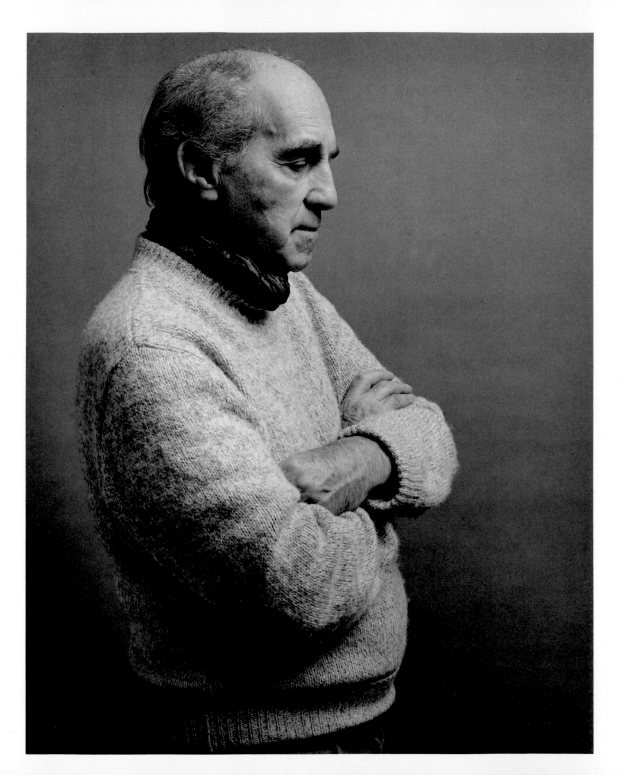

**I** sense a preordained order in the universe. Within the preparation of the great solar system of billions of years in which we live and love and disobey, we are reminded by the magic around us of the creation of the sea, the light, the wind, the rain, and the first amoebic stirrings that developed into the myriad rich and profound manifestations we are submerged in. Occasionally we are so much impressed by a hint of the magic that we try to express it in the best and highest form we can. Through song, or works, or painting, drawing, and sculpture. Or the making of some exquisite small form

of beauty as a gesture. If we remain impressed enough, we desire to do something of a deeper aesthetic nature.

Whether the condition of the world in its light and dark hours changes greatly for the enlightenment of man, he still is a *Night Swimmer* among its mysteries.

For many years when asked what I most hoped to achieve in paintings, my response has not changed: I hope to use the human figure symbolically.

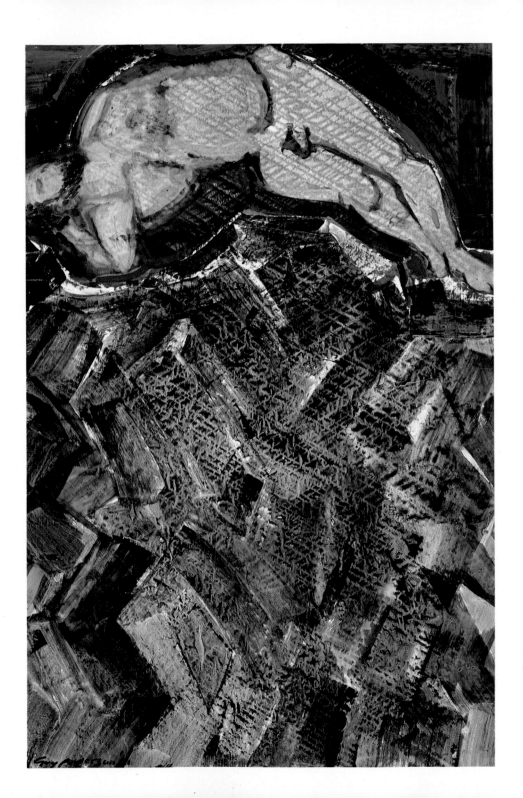

*Night Swimmer* • oil on paper on board • 1982 • 72″ by 48″

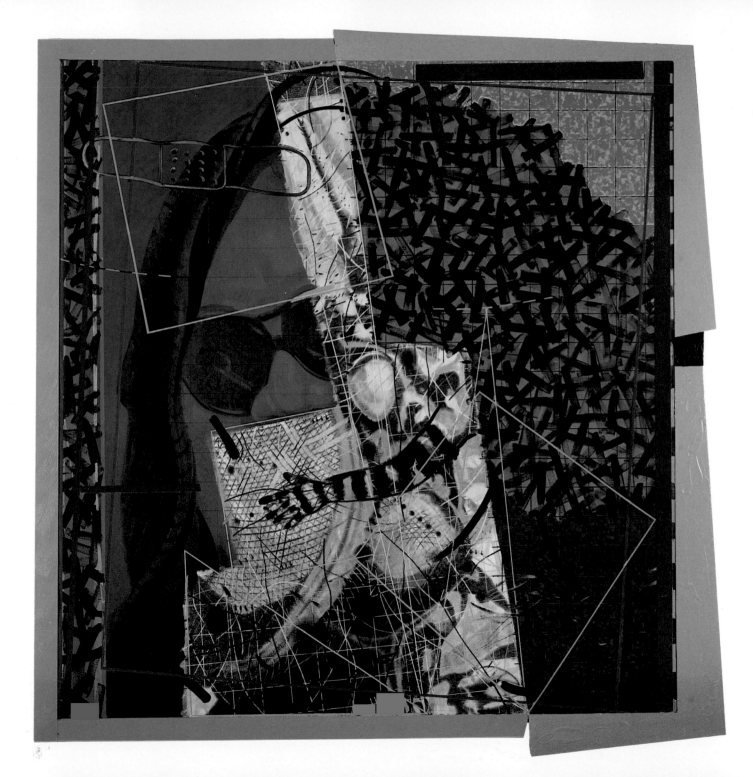

I was a youth in the 1950s, a difficult child prone to dreaming my way through my problems. After the military, through accidental good fortune, I found myself in art school. It was a positive and formative experience and gave me a sense of purpose.

In 1979 I accepted a commission for a portrait that was to be painted from a black and white photograph. This led me to further explore the photographic image in my paintings. One image I frequently used was of Joe Hill, the union organizer of the 1930s. This image, in turn, led to a progression of paintings that became increasingly elaborate and extremely complex.

For relief from this activity, I turned to some smaller photo montages I had been working on for a year; they were made from pieces of photographs from a *Life* magazine from the 1950s that showed a Chicago gangland murder. These disparate and desperate images lent themselves to a direct and aggressive kind of painting that reflects my current concerns in a straightforward way: a sort of blitz approach to that which had become too complex.

I try to contain and dignify that energy and intensity by building an architectural frame around the images. *AWW-FREE-CAN-MIT-BANN-D-AID* is one of *The Desperate Image Series*.

*The Desperate Image Series #10:*
*AWW-FREE-CAN-MIT-BANN-D-AID*
mixed media · 1982 · 101″ by 94¼″

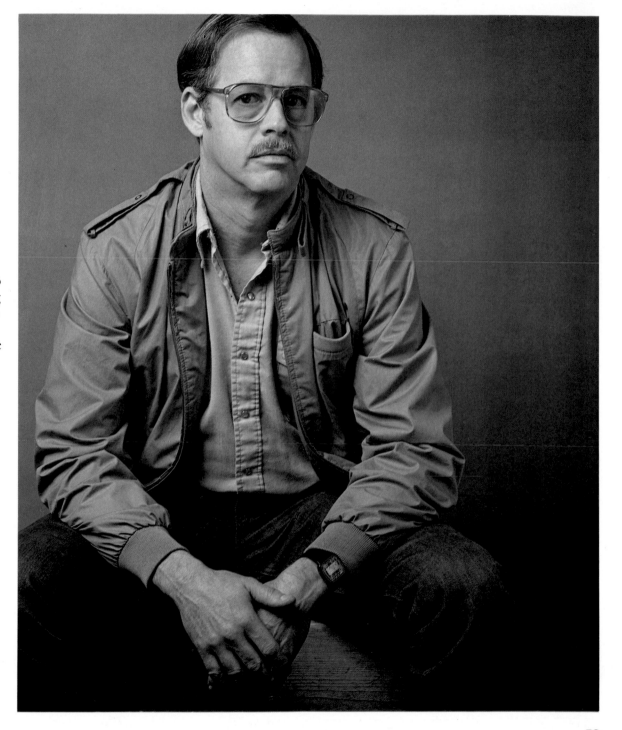

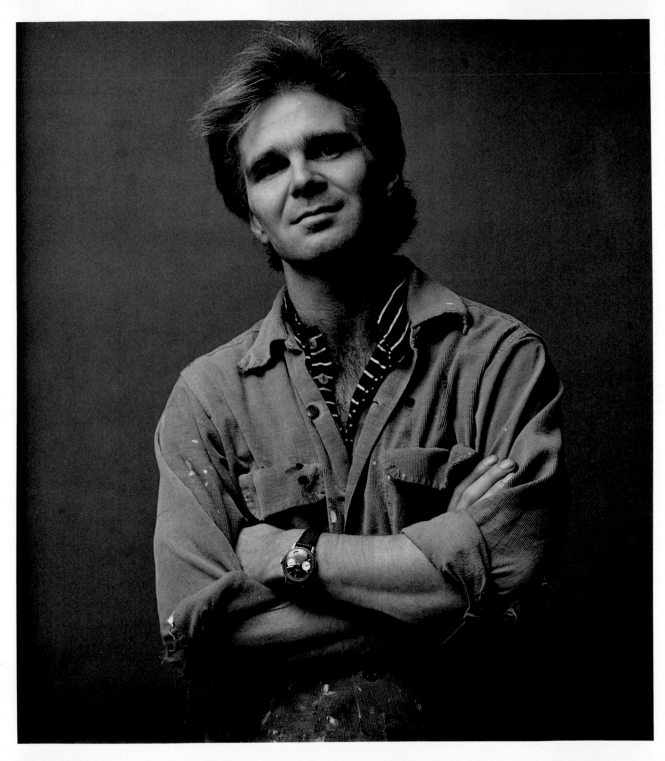

Jeffrey Bishop

**M**uch of the work of the last few years has been about personal projections in time and space.

Since childhood I've had repeated dreams of floating in various mediums. These are images and feelings of suspension and extension where weights and distances are in a fluid continuum of extreme speeds and juxtapositions in space. These, I suppose, became metaphors for locating self in the space of the world, physically and cognitively. For some time, I've also had repeated, darker dreams of nuclear holocaust.

Recently, abdominal surgery left a profound impact on me, including disturbing images. I remember right after sedation being wheeled down narrowing corridors, seemingly faster and downward, lights overhead flashing by dimmer in a darkening tunnel. As I was losing consciousness I felt outside of myself, floating: it was hard to locate my own fear.

Concerning the paintings, these lines from Wallace Stevens's poem "Sea Surface Full of Clouds" have stayed with me: ". . . a too fluent green/Suggested malice in the dry machine/Of ocean, pondering dank strategem." Words about problems of vision become dissonant and subversive in images of submersion. A periscope is needed.

Mirrors. Images that evoke, I hope, sea, and feelings about space, but are essentially non-referential and abstract. Words become equally abstract, suspended, obstinate. I am interested in an image that is a mental complex of sensory projections. A physics of phenomena, perhaps. Personal trajectories mapped on a schematic of causality.

My father was a physicist. I'm lousy at physics, and all kinds of mathematics except geometry. I prefer it this way, like lines from Beckett grappling with inertia in a topology of syntax.

Mostly I am interested in making images that might be as provocative as they are, I hope, attractive and aesthetic. Dialectics, one image provoking another.

*Projections Series #5* · acrylic on canvas · 1982 · 61″ by 96″

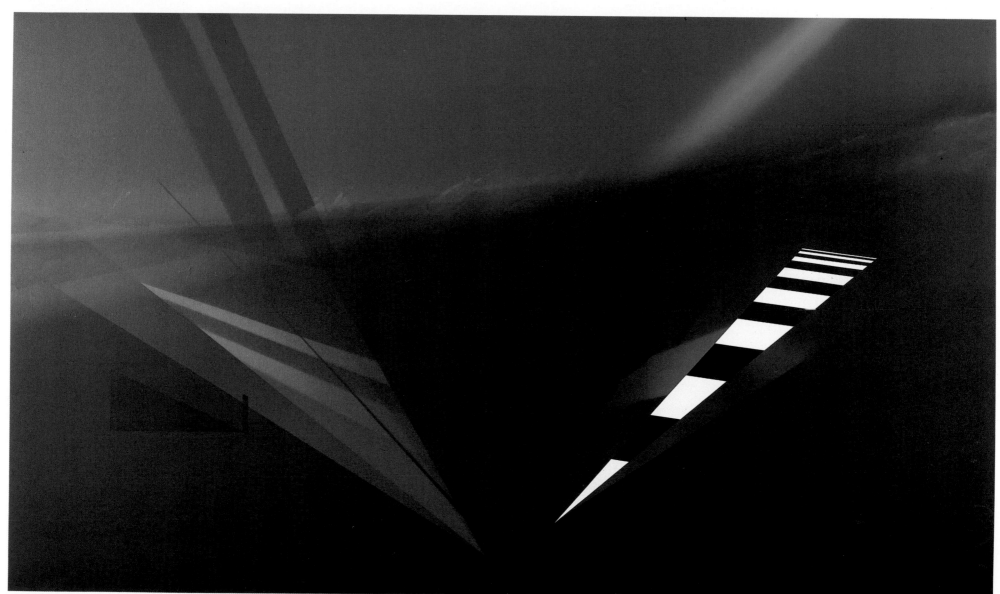

Joan Ross Bloedel

When you look at my paintings you see colors, formal shapes, and wild shapes. The paintings are visual experiments and discoveries: they all start out with a certain logical structure and end up a newly discovered world. They try to encompass the world, which is a lot to try to do, but which is what all artists try to do in their work, as far as I can tell. I want to express my personal concerns and feelings about life with some specially chosen visual ideas. For me, my paintings are more than abstract shapes and systems of color dynamics. If you can see in them a personal and human meaning, they will work best for you. I hope that you can see that, and that they will communicate and offer a vitality to you. Then their meaning won't be hard to find, if meaning can ever be found.

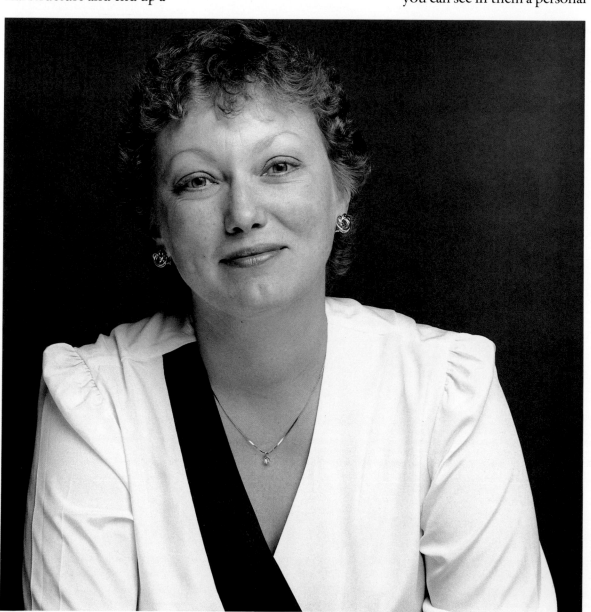

My education includes the encouragement of my parents, Lulu and John Ross, and of my early teachers. I became committed to painting when, at eighteen, I was struck by a painting by my college teacher, Richard Lukosius. It was hung in a gray hallway, and I was overwhelmed by the red, by the paint, and by the emotional brushwork. I have also learned a lot from the work of van Gogh, Marc, Mondrian, Munch, and Nolde. After graduating from Boston Latin School, Connecticut College, a year of graduate work at Yale, and advanced degrees from the University of Iowa, I came to the Northwest in 1968. The color here is brilliant to me, especially the reds and the greens.

The *Play Within a Play* series of paintings is ongoing and developing. The inner "play within a play" portrays hidden mysteries or simultaneous alternative solutions to a dilemma. These paintings are about a rich spatial environment, our place in the world, and the energies of an act of nature.

*Play Within a Play XXII*
acrylic, pastel, and pencil on rag
paper · 1982 · 50″ by 76¼″

**M**y father had been a student at the Art Institute of Chicago during the Depression. He was forced to quit school but maintained his interests in the arts. He encouraged my brothers and me to pursue our creative instincts.

Lots of artists and people have influenced me.

Living out West, in Montana, where nature is such a predominant force, my approach to life, as well as making art, has changed. I feel that my work is much less predetermined, and much more spontaneous than before.

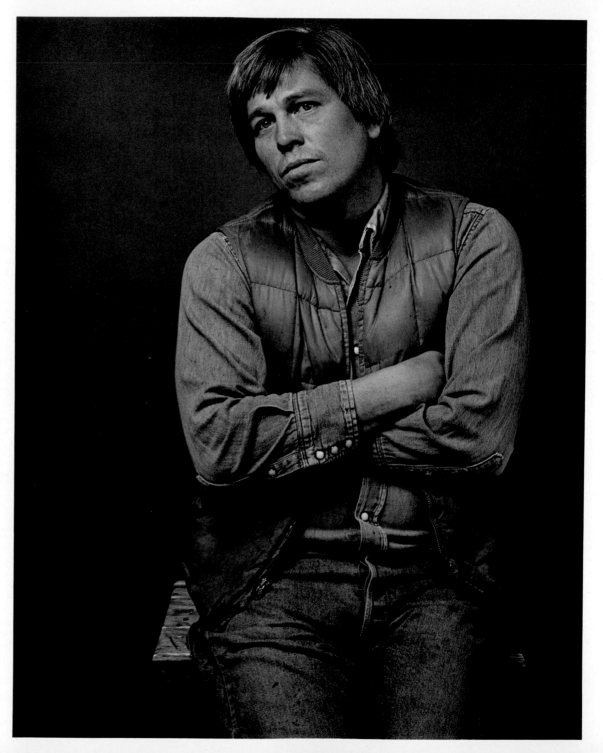

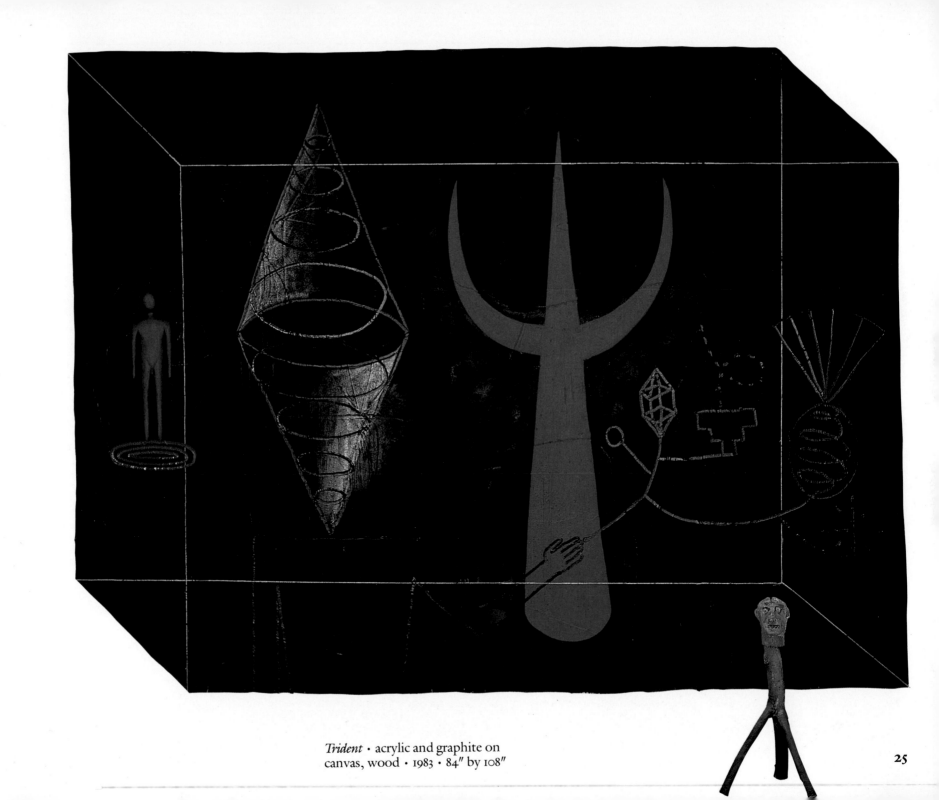

*Trident* · acrylic and graphite on
canvas, wood · 1983 · 84″ by 108″

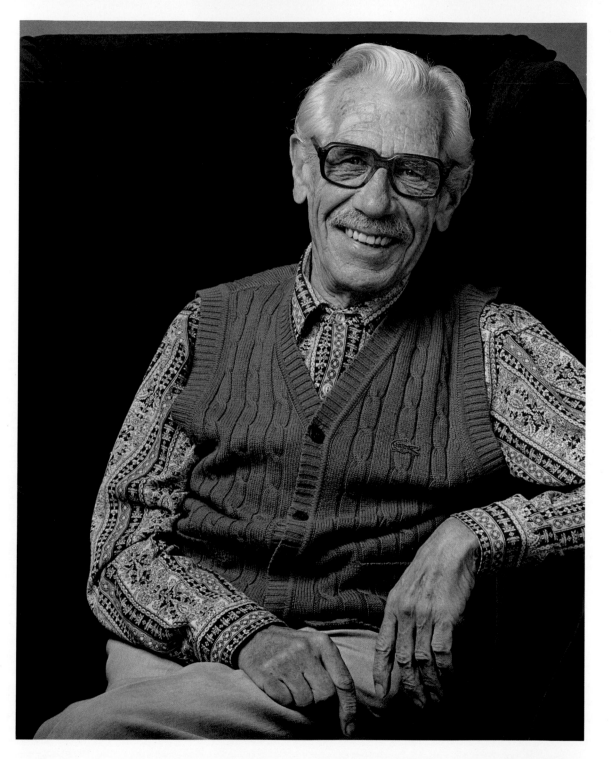

Louis Bunce

I have always been visually drawn to the landscape—at first, during my childhood in the desert and mountain regions of Wyoming. Later, I came to know and experience the lush and gentle color of the Pacific Northwest, and the urban landscape of New York City, where I attended the Art Students League and was exposed to the great paintings of the past and present.

My own credo has been to be absorbed by painting and life—to pursue them daily—to disregard what has gone before and not plan what might come tomorrow.

*Sea Sentinels* is one of a lengthy series of paintings using the subject of the coast of Oregon: its quiet seas and rockbound coves, its light and space; the sands and vast skies; storms and still evenings. *Sea Sentinels* is painted with thin layers of oil pigment laid one over the other to create the feeling of inner light. The two heavier rock forms and their placement create a tension between these forms and the close valued spaces for sea, sky, and sand.

*Sea Sentinels* · oil on canvas · 1982
50″ by 68″

I was born on May 7, 1949—the seventy-fifth running of the Kentucky Derby.

I live in Montana because it provides a more "real" environment to work in, since my art and life focus on horses. *Black Beauty* really *is* one of my favorite books. I think I prefer to look at American Indian art.

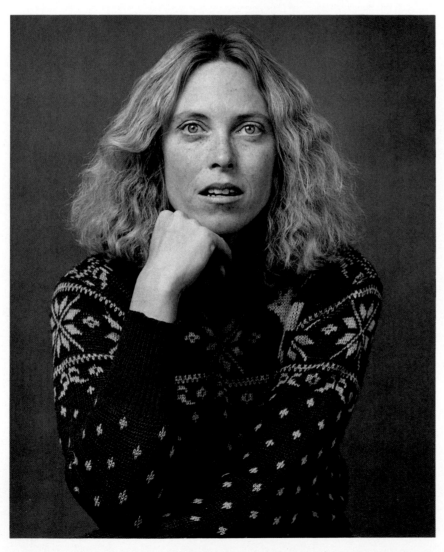

I first used the horse images as a metaphorical substitute for myself—it was a way of doing a self-portrait one step removed from the specificity of Deborah Butterfield. These first horses were huge plaster mares whose presence was extremely gentle and calm. They were at rest, and in complete opposition to the raging war horse (stallion) that represents most equine sculpture.

The next series of horses were made of mud and sticks and suggested that their forms were left clotted together after a river flooded and subsided. They were dark and almost sinister, reflecting the realization that I was perhaps more like the war horse than the quiet mares. For me they represented the process of attitudes and feelings taking shape after a "flood" of experiences. The materials and images were also meant to suggest that the horses were both figure and ground, merging external world with the subject.

The more recent horses incorporate found materials, all having their own history and diverse visual qualities. Often, finding the "right" material when you need it is next to impossible and fate tends to determine what you will find and when. I always work to make the personality of each horse dominate and overrule the identity of its sum parts. These horses are rarely hollow shells, but are built up from within and reveal the interior space. The gesture is contained and internalized while the posture is quiet and still. Action becomes anticipated rather than captured. Each horse represents a framework or presence that defines a specific energy at a precise moment.

I ride and school my own horses (and am schooled with them!) and feel that my art relies heavily upon, and often parallels, my continuing dialogue with them. I am more and more interested in how each horse thinks, and hope that my work begins to *feel* more like horses than even to look like them.

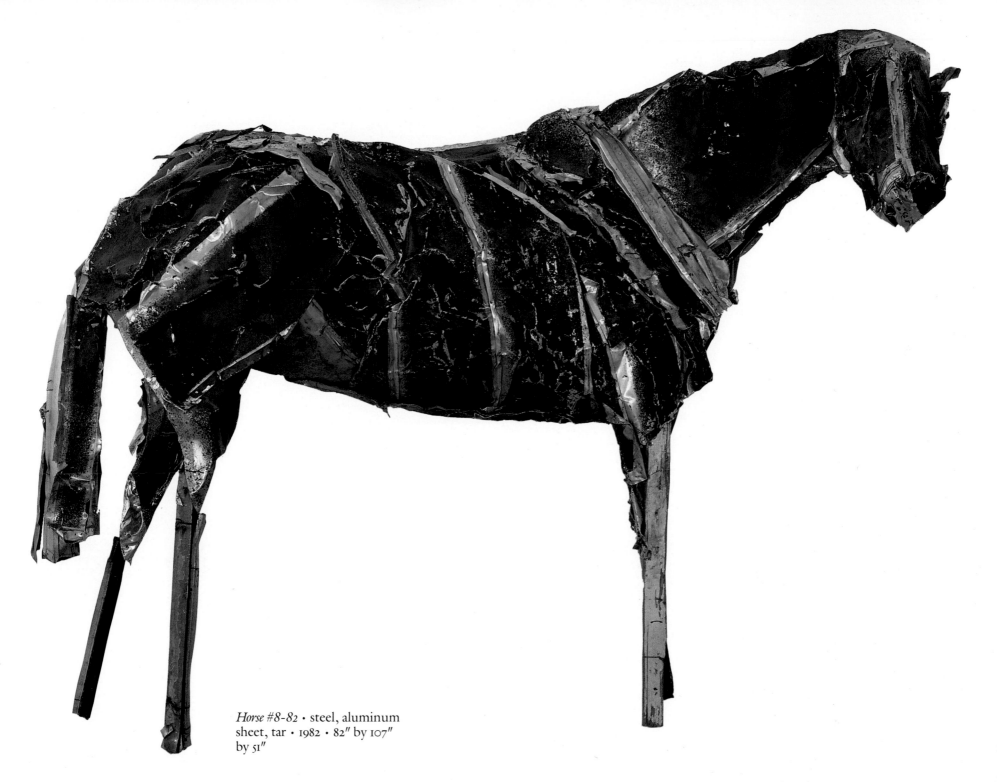

*Horse #8-82* • steel, aluminum sheet, tar • 1982 • 82″ by 107″ by 51″

Kenneth Callahan

**I** have been interested in art since I was eight or nine years old in Montana. I liked the work of an Indian painter, and Charles Russell; paintings of horses, cattle, and round-ups. I started with a cartooning kind of illustration that developed into a commitment to painting itself.

I illustrated a children's book for *Treasure Chest* magazine that was published in San Francisco in 1926. I worked at sea as a merchant sailor, at a night branch of a bank, at an art museum, and as an art critic —always part-time, though, to allow me time to paint. Never did I have the slightest intention of taking on any of these jobs as a lifelong profession.

A great change came for me in 1927, when a friend brought Madame Scheyer to my studio. She had come from Germany with a large folio of watercolors, drawings, prints, and gouaches by Klee, Kandinsky, Feininger, and Jawlensky. I realized then that naturalistic, traditional form and color were not enough. Ever since then I have attempted to make my own art vital and alive.

*Odyssey* is a recent example of my continuing search for basic earth movements— rhythms experienced by the outer eye through the inner eye.

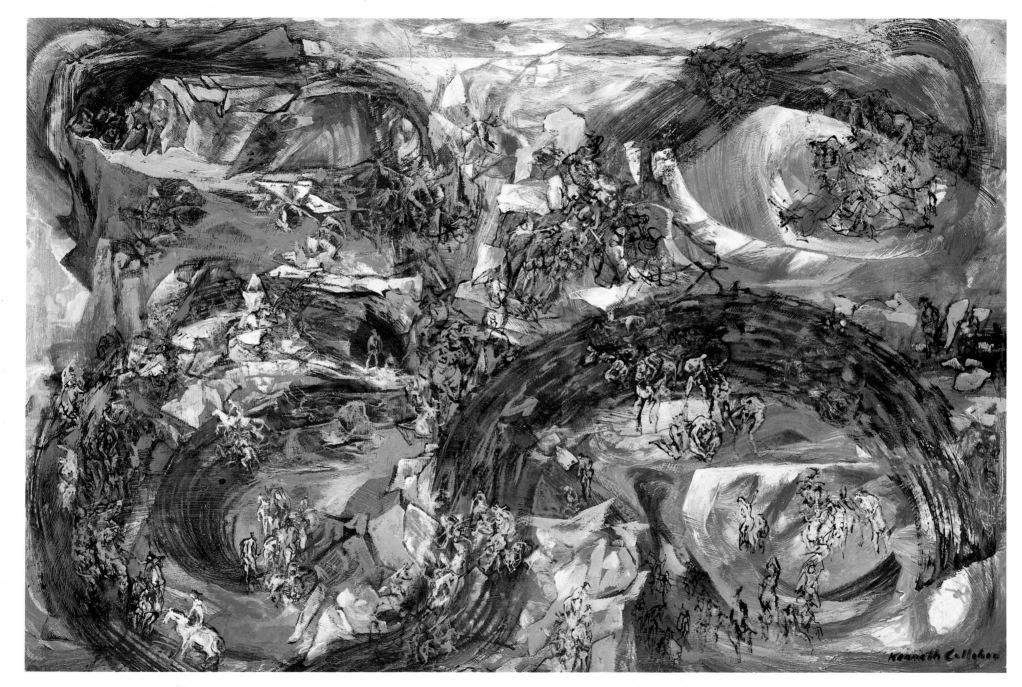

*Odyssey* • oil on canvas • 1982
39″ by 58¾″

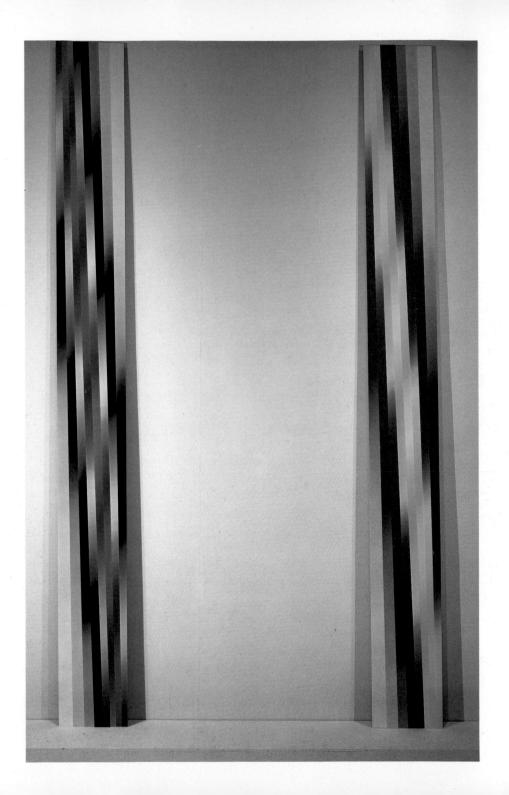

**I** was born in New York City in 1928. My interest in art developed as a high school student. Later I was inspired by Philip Guston, who was teaching studio courses at the time at Washington Square College, New York University, where I received undergraduate and graduate degrees in art history. I am presently Professor of Painting at the College of Arts and Sciences, University of Washington, in Seattle.

With regard to my background as a painter, I began as an abstract expressionist from 1951 to 1962, with mingled influences of surrealism, cubism, and the art of Mondrian. During the years 1963 to 1965 my work shifted to hard-edge painting in black, white, and gray with very little color. From 1965 to 1968 I became concerned with an aggressive optical surface involving the manipulation of black and white shapes as a means of

*Pendenza #4* and *#3* • acrylic on plastic • 1978 • 118″ by 10⅞″ each

generating intense visual fields of energy. Then, in 1968, I became interested in color dynamics and studied the experiments and theories of M.E. Chevreul and others and began my first air-brush paintings composed within the ordered confines of vertical sequences on canvas. In 1972 I began to air-brush paintings on plastic, cutting and rearranging them in a variety of sequences. The present work is an extension of this direction.

This direction asserts an art that states my position clearly. Means are simple, combinations complex. A variety of spatial orderings and orchestrations of color generates tension that reflects my concern with a dramatization of pure visual means. In this way the artwork functions as a stimulus of perception in which movements of structure and color are perceived to be simultaneously interdependent and opposed. This is because I conceive of the artwork as a direct instrument of my sensibility.

The two paintings illustrated belong to the *Pendenza* series, meaning gradient or slope. This series is one of many that earlier explored a different problem of tension/resolution between structure and color. As can be seen, each of the *Pendenza* paintings illustrates this tension, but in addition they are narrow parallelograms that lean against the wall from their base, revealing the delicate thin edge of their plastic support and generating a slight sense of imbalance. The absence of traditional framing treatment creates shadows laterally, in muted color, by reflective light from the painted surface on the back of the paintings. Here I have extended my concern for the interaction and metamorphosis of color and structure generating ordered entities of exquisite tension framed in a halo of their own light.

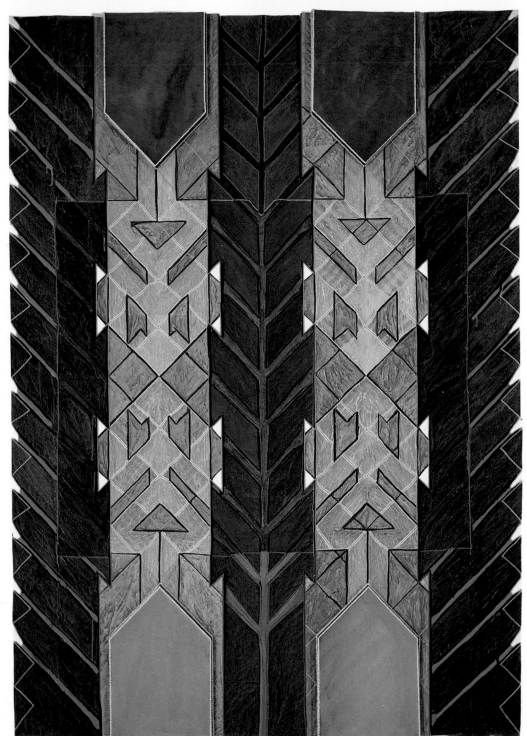

Jack Chevalier

*Animist Vibration* • paint on
carved, interlocking wood panels
1982 • 64½″ by 45½″

Once I took a walk in the woods. The trees were illuminated against a moonlit night in a way that made them appear as a kind of energy field—like lightning bolts shooting up from the ground. It didn't happen fast or in a flash, but very slowly and quietly, without thunder.

My artwork is about making this kind of connection between things, to see how energy might move through things—to make a picture out of it.

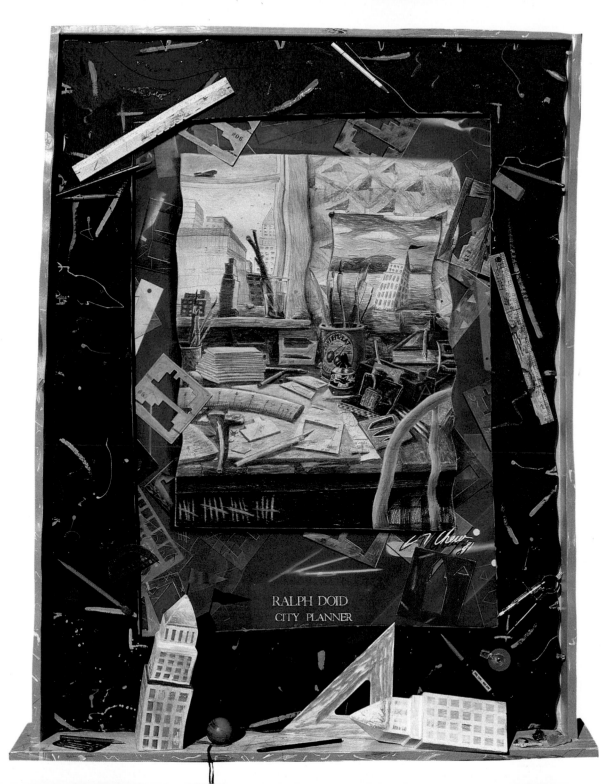

RALPH DOID
CITY PLANNER

My father was half Chinese, half Irish setter. My mother, an intriguing organic labyrinth. At an early age they sent me off to sea with Charles Darwin on the *Beagle*. It was while I worked at his side, and later with Gloria Vanderbilt in China uncovering the remains of Peking Man Wardrobe, that I invented one of life's greatest mysteries: Truth in Advertising. Today, total devotion to this ideal keeps me in demand worldwide. Recently, I dedicated my newest monumental work, *Tomb of the Unknown Folder,* in Manila. I love the grandiose.

*Ralph Doid's Dilemma* is a memorial work. It is fifty feet high and thirty feet long. The buildings are actual size. Ralph was a Seattle city planner (1923–1947), with some great ideas that no one would listen to. After a long and frustrating career he decided to revenge himself on the powers that be, with designs for a "floating" city hall. In this scene, Ralph is having trouble deciding whether the building should bob up and down, or drift on its side.

*Ralph Doid's Dilemma* · mixed media · 1981 · 45″ by 36″

37

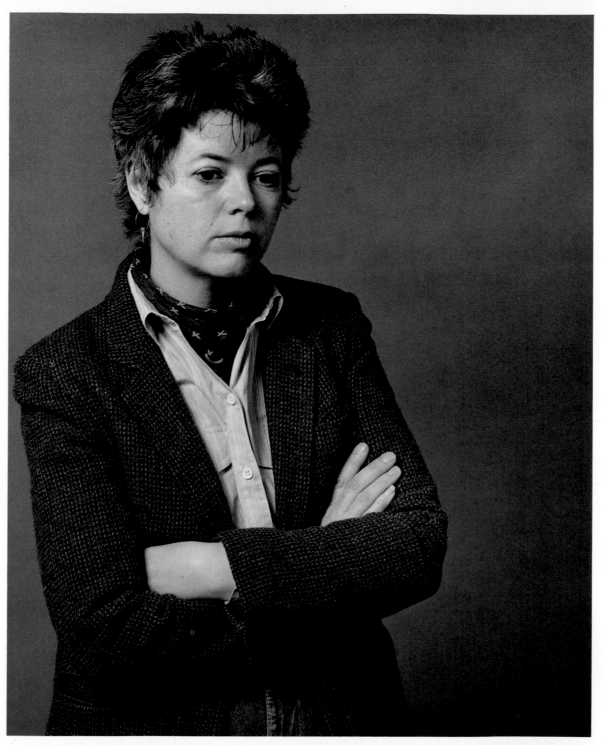

Judy Cooke

As a kid growing up in Michigan, I was either interested in making pictures or in reading. I still am. My earliest impression of seeing art was visiting the Detroit Institute of Arts, an exhibition of paintings by Jacob Lawrence about John Brown. The color and the story fascinated me.

I left Michigan when I was eighteen and went to a school outside of Boston, the Cambridge School of Weston. The classes were small and the scheduling allowed for blocks of painting and writing time. An English teacher there, Hal Sproul, was especially fine. His classes helped me to integrate my writing and painting activities.

Travel is important to my work. A grant from the Boston Museum School, some years later, allowed me to travel for

nine months in Europe, England, and Morocco. The non-European aspects of North African culture have stayed with me as vivid visual experiences. They still motivate my work.

After I returned from Europe, I worked with collage. The scale and variety of shape and line in Marca-Relli's work influenced me.

Painting is a process of discovery for me. A way to travel. Some days are terrible, with no sense of progress. Other days are extraordinary and a painting arrives like a gift. *Red Veld* is one of a group of paintings I have been working on, based on reading several novels of Nadine Gordimer and on thinking about Africa.

*Red Veld* · oil and wax on canvas
1982 · 62″ by 52″

In "An Essay on Man," Ernst Lassier wrote, "In language, in religion, in art, in science, one can do no more than to build up one's own universe —a symbolic universe that enables us to understand and interpret, to articulate and organize, to synthesize and universalize our human experience."

The notion is not new—an arboreal alphabet—a lexico-graphic hieroglyph—or even an orthogonal cryptograph using constellations and

Dennis Evans

interstates as choreo/geographies. Yet it all leads to a lot of hoopla, and concocted notions, and an immense need to understand, order, and classify.

Then there is this desire for Utopia. From the Druids, to Sir Thomas More, to the Jesuits, to these newfangled root venerators, they all had some twisted desire for Transcendency . . . and what they all did to achieve it! It all seems, I suppose, as just another way of beating the Averages. But back then, concealing it was going to get you a lot farther than revealing it, and as time would have it, such hermeticism only spawned specialists, yep, selling Special Lists, new splits and new percentages, (CABAL)LISTS they call them. So you buy the list and then you *get* it. That is, until the new List hits the charts, but that's right, close behind comes the Second Derivatives —functions of functions a never-ending cycle until . . . the NEW × L and then . . .

In 1975 the Institute for the Conservation of Ephemeral Events was founded as a theoretical study unit for the advancement of research into "The Another Not New Notion." I.C.E.E. devises twisted concepts, develops and manufactures test apparatus and field tests, both theoretical concepts and equipment, all with the implicit intention of keeping the Averages out of reach, or at least keeping a moving target. All of this is because the I.C.E.E. has an almost unnatural desire to double-cross that old keepsake of Western culture, *eidos,* and restore to our rather mundane daily rituals a sense of old-fashioned wonder, and humor.

*Transversals to a Flow with a Hundred Rainbow Zero Entropic Driftola* · mixed media · 1979

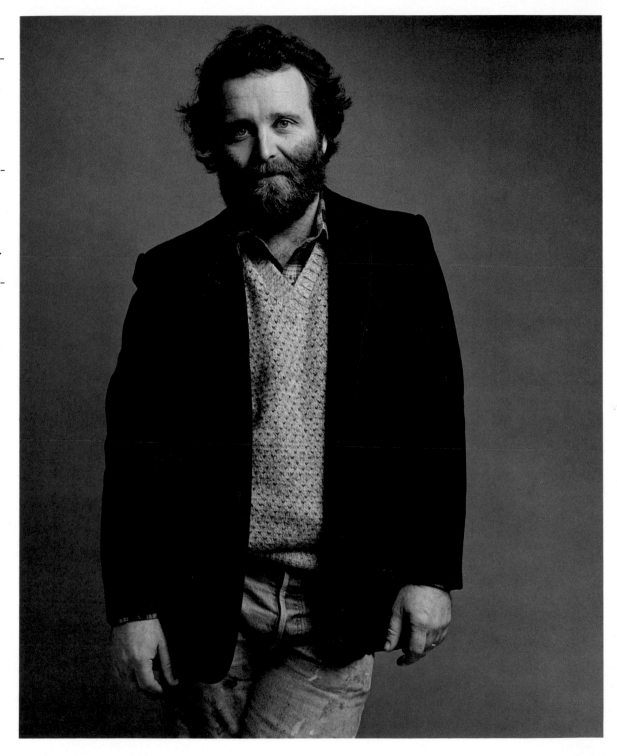

Gaylen C. Hansen

**I** was born and raised on a farm in Garland, Utah. Now I live and paint in the small, charming town of Palouse, Washington. Since I do live in the country, rather than in the city, the images in my paintings are country images.

For the past thirty-seven years, my occupation has been teaching art in institutions of higher education. Last spring, after twenty-five years of service, I retired from Washington State University. Now I am a full-time painter.

Some of the things that please or affect me are strong simple forms, playfulness, humor, archaic dogs, unusual juxtapositions, stampedes, leaping fish, the bold maneuver, a decisive painting act, a specific placement, growing more eccentric, the explorations of Lewis and Clark, the Palouse moon rising full and orange, red grasshoppers, small-town parades, fearsome creatures lurking in the darkness, campfires, feeling light of foot and sassy, open space, dreams, getting up before sunrise, the Universe, fly-fishing on the North Fork, a sense of place, presence, good friends, volcanic eruptions, trees, love, rocks, tulips, cowboys on horseback, enchantment, setting forth, clear mountain streams, and truth artfully stretched.

*Black Cat Attacking Stag* · oil on canvas · 1980 · 56″ by 73½″

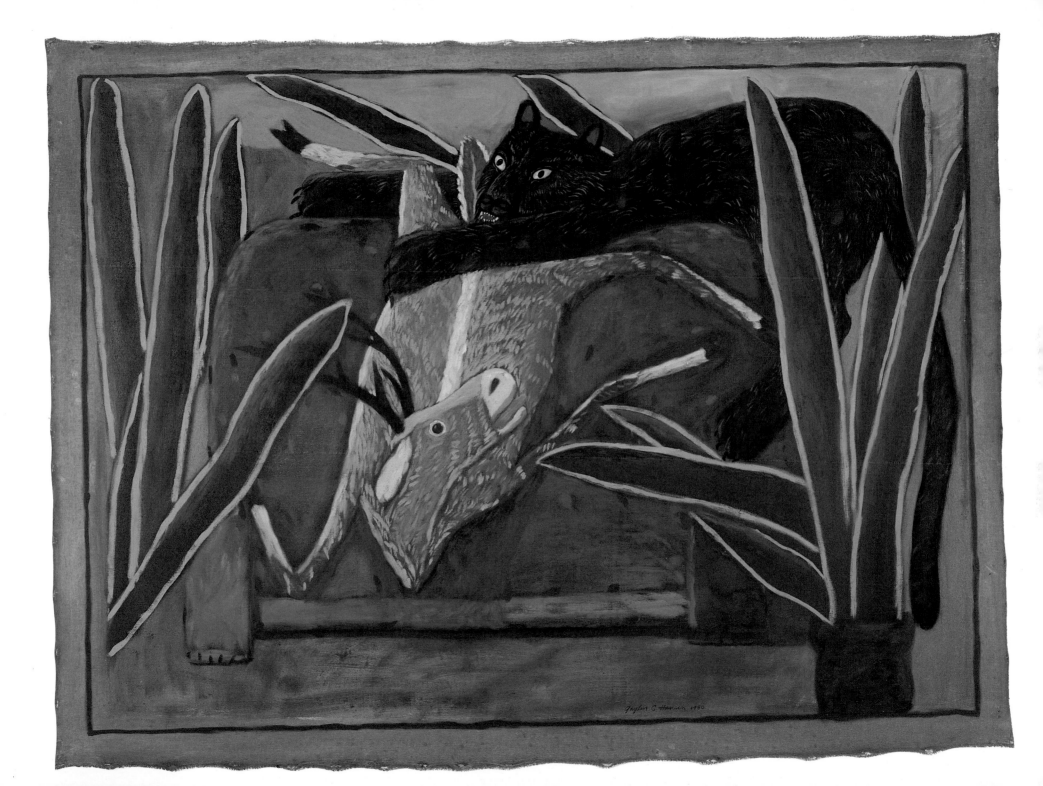

There was little visual art to influence me in Mississippi as I was growing up. There were no art museums or galleries. The art that I did see was mainly sculptural monuments to those who fought in the Civil War. In a sense, the first musuem I encountered was the National Park Cemetery at the site of the Battle of Vicksburg.

At the age of ten, I traveled with my family to Washington, D.C. I missed my first real art museum opportunity, however, as I sat in the car with the rest of my family while my mother quickly took in the National Gallery.

Later, a high school friend, Ke Francis, and I shared a set of oils that he bought at a Sherwin-Williams paint store. We painted simultaneously on the same canvases. I think the first oil paintings I ever saw were my own.

There were times in art school when I felt I was the only student there getting a degree in drawing. I studied sculpture for three years at a liberal arts college before transferring to an art school. I was so far behind in drawing requirements that I had to take drawing classes six hours a day, for as many as four days a week, for the next three years.

I tended to think sculpturally and so I paid little attention to major two-dimensional concerns such as figure-ground relationships and composition. When my professors insisted I utilize the entire surface of the paper, my solution was to cut the figure from the ground so that I *was* using the entire surface of the paper. These cutouts also shared, with sculpture, a strong emphasis on silhouette.

Another result of so many hours spent on drawing was that I experimented with many kinds of material to escape boredom. I discovered pastels about the same time I began the cutouts. The Plexiglas used to frame and protect the pastels seemed to reinforce the sculptural origin of the drawings. By adding color and enlarging the scale to life size, I began to see drawing as equivalent to painting and sculpture and, in fact, the work had become a hybrid of the three.

Finally, at the same time, I became interested in very specific subjects and began to photograph models outside of class. This put me in the ludicrous position of drawing from a photograph while the rest of the class drew from a nude model.

Randy Hayes

I made only six or seven sculptures after I graduated. At times, I have abandoned the cutout and pastels but I keep coming back to them. When I have used a rectangular shape, the rectangle itself was a silhouette, like a window or a phone booth. Some of these pieces were a conscious attempt to return to using a live model. To force myself to do both, I built a shadow box about the size of a phone booth and drew models from life as they stood inside the box. Toward the end of this series I thought I would try a visual pun and ask a boxer to pose in the shadow box. This literal connection, between box and boxing, caused me to visit a gym and eventually resulted in pieces like *Saved II*.

Moving from a boxed figure to a boxing ring shifted the emphasis from the individual to the group and from a form of estrangement to a form of engagement. Boxing, and other subjects I am now working on, are events witnessed by an audience, as is art.

*Saved II* · pastel on paper, cutout Plexiglas · 1982 · 90″ by 186″

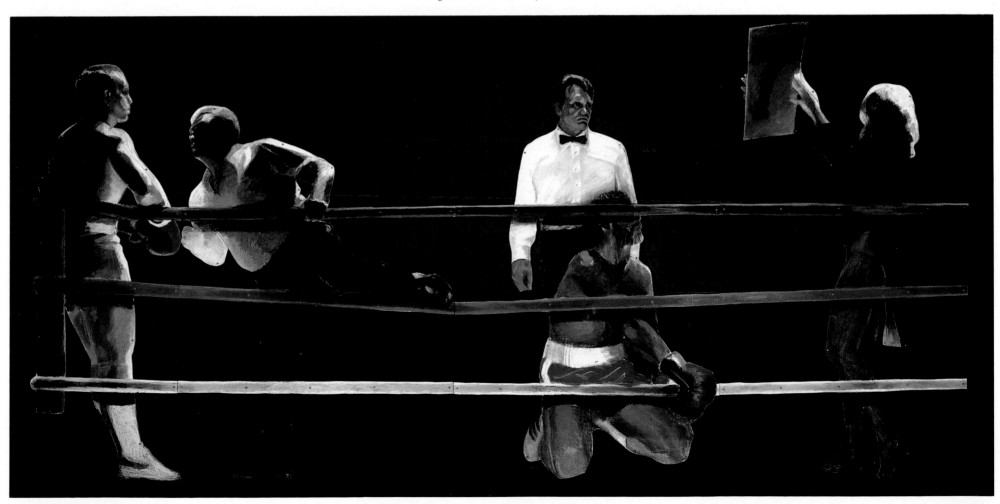

My formative years were spent on the shores of the Great Lakes and on the network of Michigan rivers. I witnessed the urbanization of many of my favorite haunts during that time and was fascinated by it. I think it helped me to maintain a balance between the urban and rural in my life, and to keep a healthy mental and visual perspective of the two.

My mother was an art teacher and my father a coach. Sports and the arts have fueled my activities, and academics have nurtured them. I was educated at Albion College and the University of Washington in the 1950s and early 1960s. Upon graduation from Albion, I set out for Seattle with the sole intention of becoming an artist. I'd seen an article on Mark Tobey's Venice Biennale prize in *Life,* or some such magazine, and I was taken by the photos of the urban landscape of the city. That, combined with the water and mountains, looked like the ideal blend for me. I've never strayed from the area for long, although I have taught in Colorado and in the Midwest for short periods. Between 1960 and 1964 I lived and painted in Marin County in California, where I also

*Die Hard* · acrylic on linen · 1982
48″ by 52″

felt at home. It provided associations with other artists who were finding creative avenues through the turmoil of the times.

From 1968 to 1973 I taught at the Cornish School in Seattle, and while I continued to paint, I put much energy into theatrical art events, performances, and animated movies.

For the past ten years painting has been my primary concern. The pictures I make are interpreted in many different ways by those who see them. Some in terms of their structure: architectural, geographical, and/or anatomical. Others respond to their color, light, mood, landscape, weather, and even mystical connotations. I am generally interested in any interpretation and response to my work, and I am often delighted to hear of aspects and possibilities that I may not have consciously considered otherwise. I am of the opinion that everyone is at least partly right in theirs.

For me, painting is an adventure. I do it to see what happens, and to maintain my own equilibrium.

I call this painting *Die Hard* in tribute to its persistence. Sometimes a work seems to happen on its own accord, leaving one surprised and pleased that it came about

effortlessly and with meaning. At other times there is conscious dialogue with a painting through which questions of its time and existence must be resolved. In both instances new ground can be broken while old boundaries dissolve: I can't judge one phenomenon to be more valid than the other.

This picture refused to remain unresolved innumerable times, and at one point I considered it finished, so I photographed it. Through its several changes and new lives, its basic symmetrical configuration did not change, which points out the difference between structure and form.

47

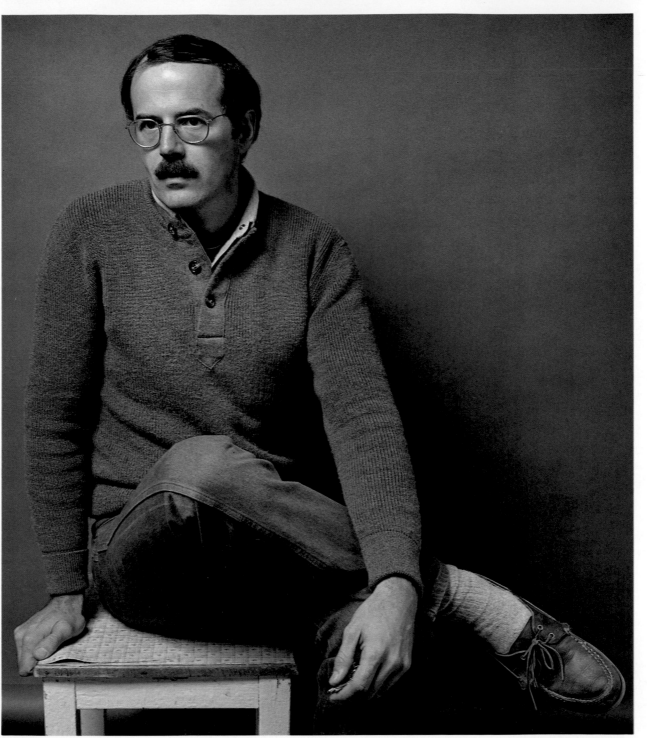

Robert Helm

I was born in Wallace, Idaho, and grew up in Spokane, Washington.

As far back as I can remember I've had the habit of revisiting, at fairly regular intervals, certain places along the strip of land at the far eastern edge of Washington and the panhandle of Idaho. The locations I return to are mundane enough: a street, a row of trees, a certain building. The compulsion to return and take another look seems to be common to most people. If these locations are curiously charged with meaning, it is probably because it is at just such places that you can meet with yourself going backward.

It occurs to me that the same feeling of retrieval comes from running across one's own painting or sculpture that has worked its way to the back of the closet over a period of years. And like the geographic locations, the work may be mundane enough, but there is the same feeling of reunion and the peculiar pleasure of visiting former haunts. The work represented here is one of those former haunts.

*She Stared Now at Her Gloved Hand, Now at the Unfamiliar Room* · mixed media · 1981 · 30″ by 36″ by 3″

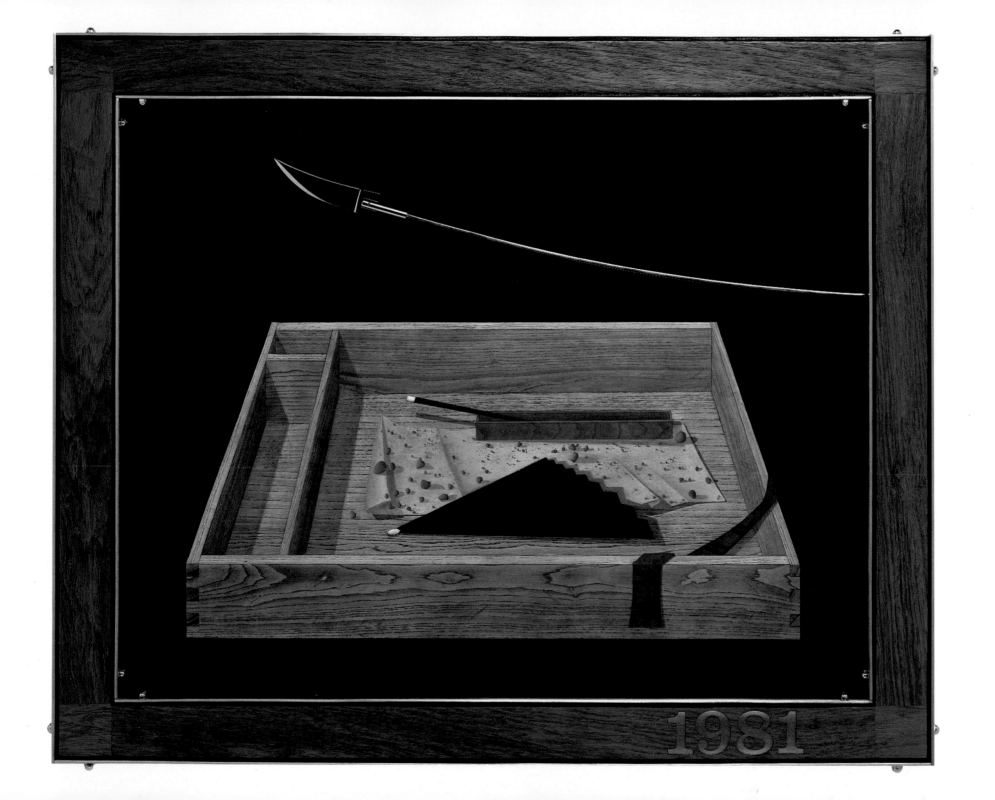

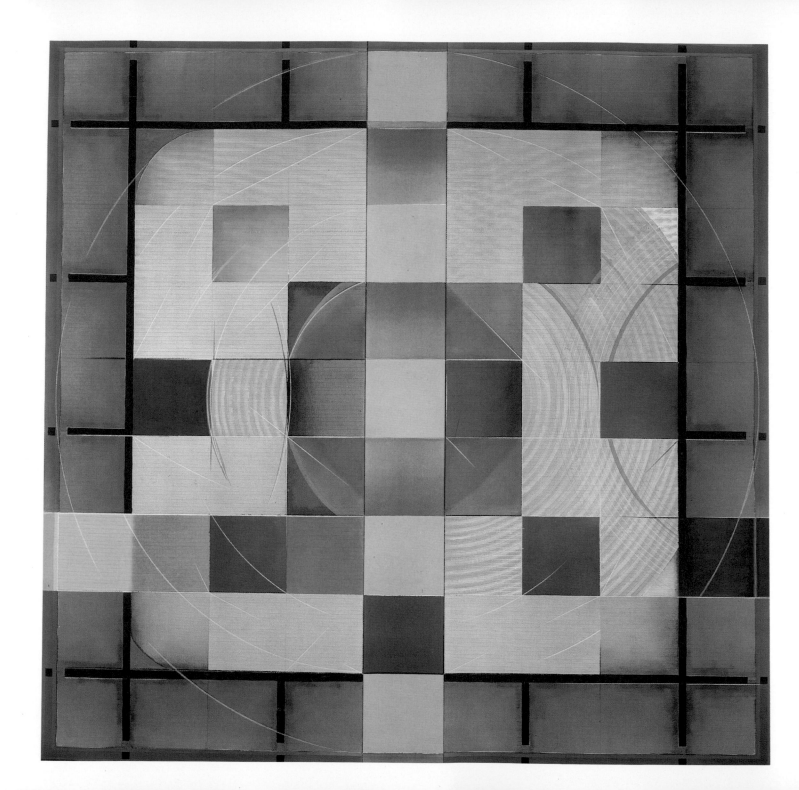

William Hoppe

I was born on October 4, 1945, in Portage, Wisconsin. When I was a small child I had a garden in which I grew snapdragons. In one half of our garage I made a circus, a school, a theater, a church, a store, a laboratory, a hospital, and even once a refrigerator.

Movies frightened me. Radio made me listen. Catholic schools filled my mind with graven images.

At twelve, I went to Madison, Wisconsin, to attend a Catholic seminary. While in Madison, I experienced my first art exhibition: paintings by Franz Kline. I saw in the paintings the same introspection and isolation I had come to know through religion.

After my expulsion from the seminary, I found myself rejecting others' word systems. I began to study art history, and I enrolled in drawing and painting classes, where I felt free to make my own way.

I like to think that my work is an unbroken line from that point.

*The Mute Siren* · acrylic and pencil on canvas · 1981 · 94″ by 94″ (triptych)

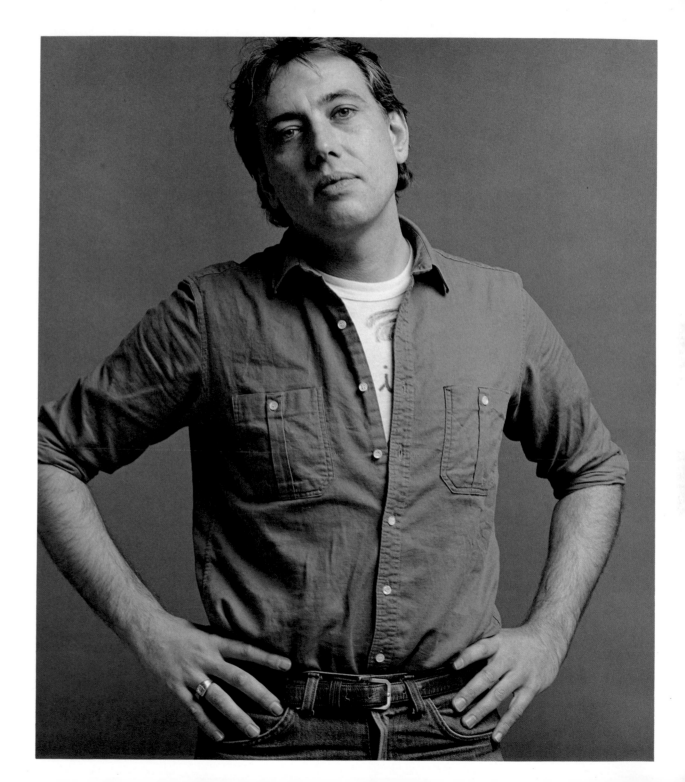

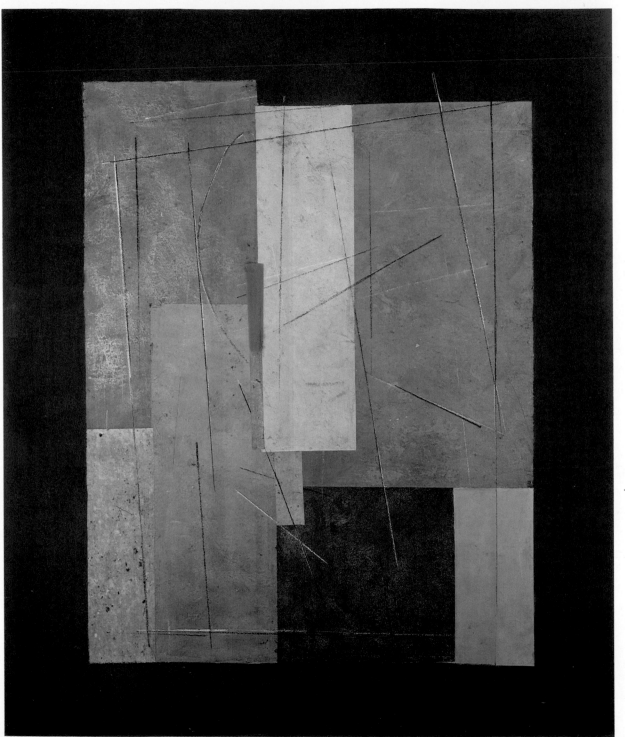

Paul Horiuchi

*Reconstruction #2* · mixed media
collage · 1982 · 74½″ by 52″

I travel to Japan, where I spent my childhood. I like the Northwest: the water, the green have some similarity to my native place.

I believe that the art of painting, and the painting itself, should convey a feeling of serene satisfaction and inner harmony.

53

William Ivey

**W**hile I was a student at the California School of Fine Art (now the San Francisco Art Institute), I was influenced by Clyfford Still, of course. But there have been others. To list them, I think, would be misleading.

I continue to live in the Northwest because my roots are here, and I haven't found anyplace else in the United States that I like better. However, I think I could work almost anyplace.

Untitled #5 · oil on canvas · 1982
61″ by 71″

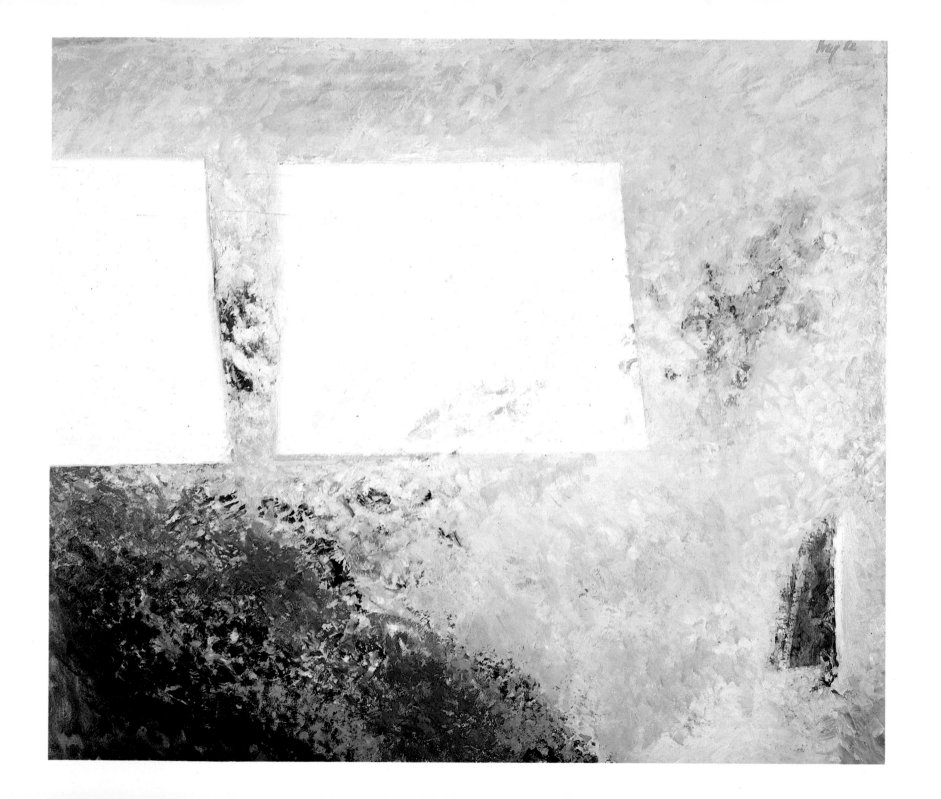

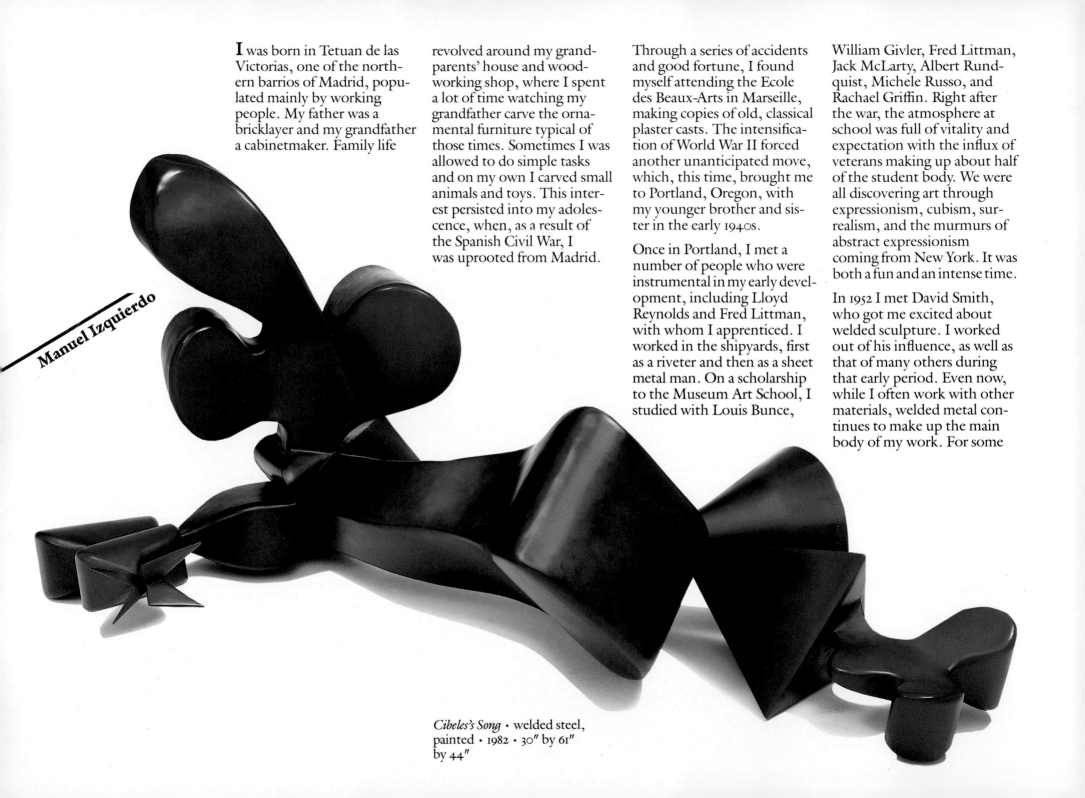

**Manuel Izquierdo**

I was born in Tetuan de las Victorias, one of the northern barrios of Madrid, populated mainly by working people. My father was a bricklayer and my grandfather a cabinetmaker. Family life revolved around my grandparents' house and woodworking shop, where I spent a lot of time watching my grandfather carve the ornamental furniture typical of those times. Sometimes I was allowed to do simple tasks and on my own I carved small animals and toys. This interest persisted into my adolescence, when, as a result of the Spanish Civil War, I was uprooted from Madrid.

Through a series of accidents and good fortune, I found myself attending the Ecole des Beaux-Arts in Marseille, making copies of old, classical plaster casts. The intensification of World War II forced another unanticipated move, which, this time, brought me to Portland, Oregon, with my younger brother and sister in the early 1940s.

Once in Portland, I met a number of people who were instrumental in my early development, including Lloyd Reynolds and Fred Littman, with whom I apprenticed. I worked in the shipyards, first as a riveter and then as a sheet metal man. On a scholarship to the Museum Art School, I studied with Louis Bunce, William Givler, Fred Littman, Jack McLarty, Albert Rundquist, Michele Russo, and Rachael Griffin. Right after the war, the atmosphere at school was full of vitality and expectation with the influx of veterans making up about half of the student body. We were all discovering art through expressionism, cubism, surrealism, and the murmurs of abstract expressionism coming from New York. It was both a fun and an intense time.

In 1952 I met David Smith, who got me excited about welded sculpture. I worked out of his influence, as well as that of many others during that early period. Even now, while I often work with other materials, welded metal continues to make up the main body of my work. For some

*Cibeles's Song* · welded steel, painted · 1982 · 30″ by 61″ by 44″

thirty years, I have devoted my time to sculpture and the teaching of it. For a number of years I was married. I have four wonderful children, some with children of their own.

I would describe my work as "figurative lyricism" in the sense that it stems from aspects of the world around me and goes through a process of interpretive gestation. I search for forms that evoke a wide range of feeling and ideas that contemplate those feelings. A particular theme will attract my attention and I will pursue it for long periods of time, returning to it over and over. I find the infinite possibilities of forms in space engrossing, and the mechanics of sculpture a constant source of frustation and satisfaction. I do a great deal of drawing, both for sculpture and for its own sake. Doing large public sculptures interests me because of its social implications. I do a lot of woodcuts, mostly in the evenings, which lead me into areas that are not accessible through sculpture. It is always my hope to share with others who view my work, my concerns and my aspirations.

I chose *Cibeles's Song* because I am particularly fond of this piece since I feel that it is different, in many ways, from my previous work. It still surprises me. I find the sprawling

horizontality challenging to cope with. The figure is both tense and relaxed at the same time, through the juxtaposition of sensuous forms against very formal, geometric ones,

all of which are asymmetrically arranged. The figure wants to alternately rest and lift itself off the ground. The strong contrast of color gives the piece a feeling of light and density. Mostly, it is a sculp-

ture about contrasts and the meeting of opposites. The title comes from archaic mythology: Cibeles is the goddess of Earth who circles the sun by day and by night.

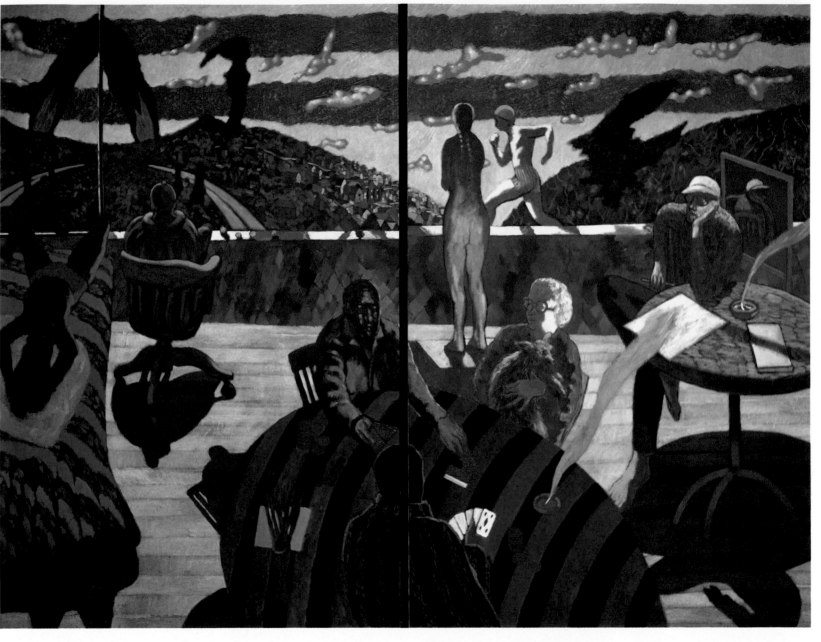

George Johanson

*Games in the Hills* · oil and acrylic
on canvas · 1982 · 68″ by 88″

**I** was born in Seattle, the year
before the Crash, of Swedish
and Finnish parents. I started
drawing at a very early age
and received lots of encour-
agement from my parents, rel-
atives, and teachers. My art
teachers in grade school talked
to me about becoming a com-

mercial artist. Magazine illustration was very popular at the time and I thought it would be a glamorous way to make a living.

A *Scholastic Magazine* scholarship brought me to Portland in 1946 to attend the Museum Art School, and I became acquainted with fine art for the first time. It was the first year after the war, and with lots of returning GI's, and new art teachers, the school was a vital place. Louis Bunce was my first painting teacher. Bill Givler, Jack McLarty, and Michele Russo were also strong and influential teachers, and they became my good friends from the beginning. A completely new world opened up for me, and by the end of the first semester, I had decided I wanted to become a painter.

The Museum Art School also gave me a strong interest in printmaking, and after my studies there, I went to New York and studied etching with Karl Schrag at the Atelier 17 workshop. I met many artists through the workshop, and also at the Cedar Bar, which was only a few blocks away. New York was a great place to be in the early 1950s.

Later, I worked for two years as a volunteer with the Quakers in rural Mexico. I met my wife, Phyllis, there and in 1955 we returned to Portland, where I started what turned out to be twenty-five years of teaching at the Museum Art School. Travel has been important, including the two years I spent in London printmaking.

I have a studio at home and divide my time about equally between painting and print-making.

I like Portland as a place to live and work. It doesn't have the art market of the big city, but it doesn't have the pressures of the big city either. For its size, there are many excellent artists living and working here.

*Games in the Hills* is one of a series of paintings presenting figures in a room or interior space and a city landscape beyond. The figures are partly portraits, partly inventions, as is the landscape. There is a mixture of pleasure and menace in the scene. Surrealism is the guiding influence behind most of my work. I want my painting to contain feelings of past and future occurrences, biography, specific observation, and invention.

Fay Jones

I have always used drawing as a way of taking notes. When I was in the fifth grade, in a small-town Massachusetts school, instead of the prescribed tree with autumn leaves, I drew, with great conviction, a fancy woman sitting on a bar stool, with a highball in one hand and a cigarette in the other. I learned early that what you make isn't necessarily going to be praised.

I attended the Rhode Island School of Design. There I discovered the films of Jean Cocteau, fell in love with the work of Piero della Francesca, and, in 1955, saw a show of Rothko's paintings, which set

free all of the boundaries I imagined enclosed the definition of painting. During and since art school I have been most deeply influenced by Philip Guston's work—his painting and his intelligence about painting.

My own work is fiction, set in the present. Caught between curious affection for history and anxiety for the future, I draw on a vivid and inaccurate memory and somewhat quirky observations of contemporary American life. I am married to the painter Robert Jones and we have four children, which is the most important counterbalance to my art.

I painted *Bird Cage* in three months, working the three panels simultaneously on three separate walls. The challenge was to keep them threaded together in my head. I am satisfied that it's well constructed and complete, a single statement. Its subtitle: *Conjuren, Attenden, Departen.*

*Bird Cage* • acrylic on paper
1982 • 52½″ by 137⅜″ (triptych)

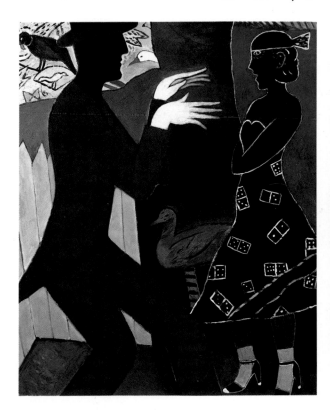 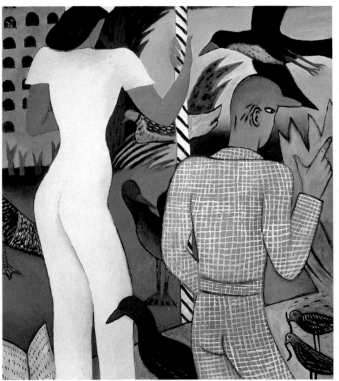 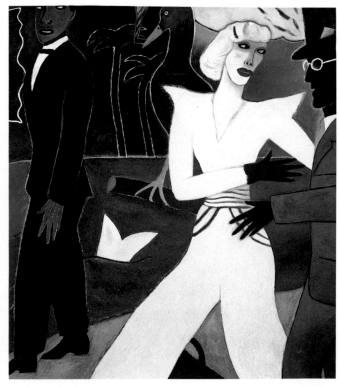

My development as an artist evolved from a melding of complementary and conflicting forces. I experienced the stability of an extended Greek-American family and the transiency of military life. We traveled extensively. By the time I finished high school, I had attended more than twenty schools. Rapidly changing stage sets. Family, art, and music were the consistent factors we shared. My parents strove to transcend the limitations of their immigrant environment by affording my younger brother and me every educational opportunity. At the time we may have objected, but the momentum and necessity of such enrichment have continued to shape our lives.

Moving from one culture to another provided me with a wealth of exposures that stimulated me to become an artist, but I lacked the confidence to be able to creatively process this information. I pursued a career in chemistry, working in a research laboratory and then teaching. Laboratories became more and more isolated from reality and issues. Lost in the precision and subtleties of others' hypotheses, I returned to school to develop my own artwork. In my painting I sought to merge a system of proportional relationships with subjective responses to glimpses of movement in isolation. Blurred figures in stark geometric spaces. There was (and remains) a scientific hangover of structure, sequence, and order.

A respect for the probing aesthetics and powerful political statements of twentieth-century German artists led me to apply for, and receive, a Fulbright/DAAD fellowship to West Berlin, where, in an attempt to visually organize perceptions of confinement, I turned to using materials that surrounded me. In collecting materials (both natural and "civilized" castoffs) I became more and more involved in using them to interpret particular site-specific problems. Sometimes these have become large-scale, temporary installations creating their own architectural spaces. Often the work involves natural residuals laminated by handmade recycled paper pieces: fragmented anecdotes of everyday life (phone books, newspapers, paper bags, etc.). I keep the paper making simple so that I can form paper directly on a site.

Diane Katsiaficas

These assimilated landscapes operate at a variety of levels. I think that society's values sway between increasing isolation from and integration with nature. Recently, in attempting to elaborate on this thesis, the installations have contained references to classical archaelogical remnants or ruins, fragmented and detached from their original intentions. I want these environments to evoke a conscientious examination of the patchwork of contemporary contradictions. It is important to me that viewers become involved participants.

*Porch* was inspired by the famous Porch of the Maidens on the Erechtheum at the Acropolis in Athens: six support a porch roof on their heads. The tomb of an ancient Athenian king, the Erechtheum, has survived all other catastrophes, only to be "defeated" by modern-day pollution. Rain, combining with air pollutants to form weak sulfuric acid, is turning the marble to plaster and then to dust. Now replaced by sandstone copies, removed from the site, and hermetically sealed in nitrogen-filled boxes to prevent further decay, the caryatids represent a complex metaphor: haunting visages of our dilemma.

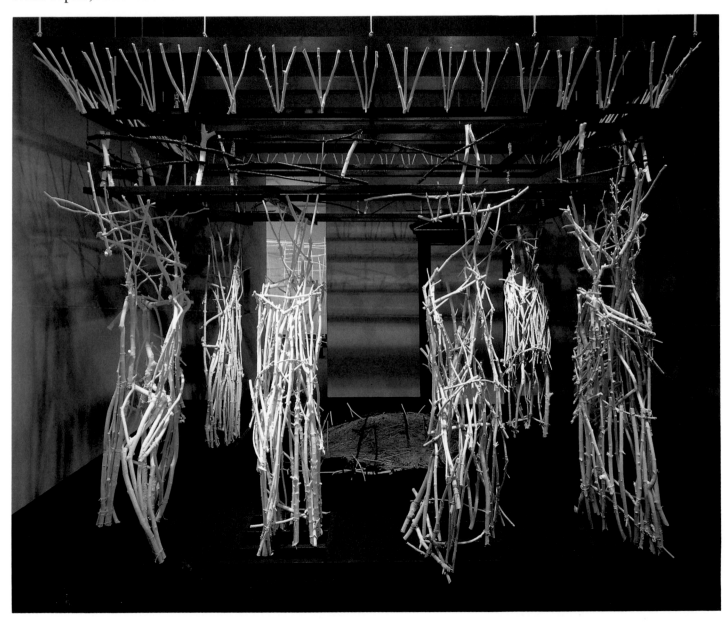

*Porch* • wood, gesso, enamel, rope, nails • 1982 • 12′ by 12′ by 8′

Mel Katz

In 1964, when I accepted a visiting artist position at the Museum Art School in Portland, Oregon, I looked forward to the excitement of living in another city, new experiences, and my eventual return to New York. Two years later, I began teaching at Portland State University, still thinking there was time for my exit. Because I realized I was becoming separated from the larger art scene I knew, I invited artists, mostly from Los Angeles and New York, to give talks and have exhibitions at PSU and the Portland Art Museum. In 1972, with Michele Russo and Jay Backstrand, I started one of the first artist-directed alternative

spaces in the country, the Portland Center for the Visual Arts. I thoroughly enjoyed my "visiting artist program," and the added attention of resulting friendships was a reasonable trade-off for the dent it made in my studio time. My ongoing efforts with PCVA's direction have given me extraordinary personal pleasure and pride of accomplishment, one of the primary reasons for my continued stay in the Northwest.

I was born in Brooklyn, New York, in 1932, and grew up in a neighborhood with its fair share of apartment houses and empty lots to play on, with friends whose parents mirrored mine. I always liked to draw and received encouragement from my family and teachers from grade school on. I graduated from the Cooper Union Art School in 1953 and spent another year at the Brooklyn Museum Art School. Gallery and museum going became a common experience as I looked hard at de Kooning, Pollock, and Kline. But, it was the paintings of Arshile Gorky that influenced me the most. Within the first year of my Portland stay my work continued to travel as I left the canvas and began making shaped paintings with lacquer-sprayed surfaces. By 1971, my process started to echo my father's work in the garment trade: pattern making, tracing, and cutting. These remembered procedures were applied to polyurethane and fiber glass materials, the structure for my polyester-sprayed pieces. Lately, I've replaced most of the plastic materials with wood. Perhaps I have acclimated to my environment.

*Chunky Series, Aqua* is a recent piece, once again exploring a new position—this time, what life's like on the floor.

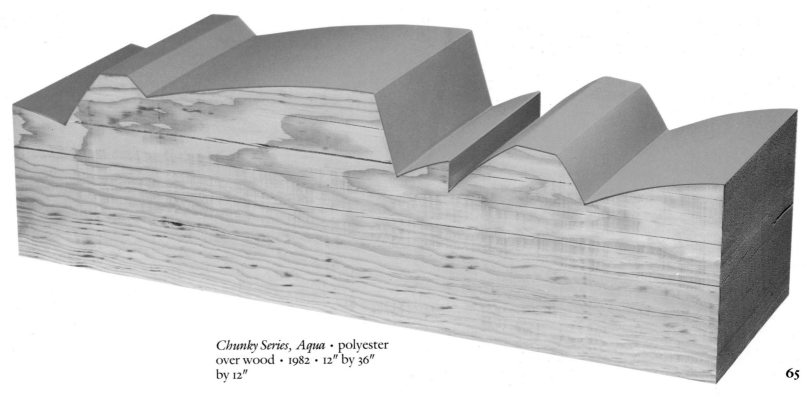

*Chunky Series, Aqua* • polyester over wood • 1982 • 12″ by 36″ by 12″

Andrew Keating

My work is informed by a poetic understanding of the biological factors and social implications of genetic engineering and spare-parts surgery. I am interested as well in the direct connection between the physical and mental implicit in phrenology, physiognomy, and attitudes pertaining to cosmetic plastic surgery. In painting, I treat all

*4 Heads* · acrylic on MDO plywood · 1980 · 24″ by 36″ each

form as if endowed with consciousness. This attitude has developed from a study of the physiological concepts of magnetism, sympathy, and the relationship between form and dysfunction in synesthetic diseases.

In terms of image, I deal mostly with the human head in partial states of being and becoming. The head provides an empathetic image and functions as a field of interaction for stylized features and signifiers. While my general goals tend toward an expression of consciousness and conflict of the individual and society, the work does not have a literal subject. For me, painting is not the illustration of ideas, nor simply the arrangement of form. It is a process of discovery that necessitates the union of intuition and intellect. The *Heads* are treated as objects, and since the means employed are pictorial, the experience of the work is also a process of discovery for the viewer.

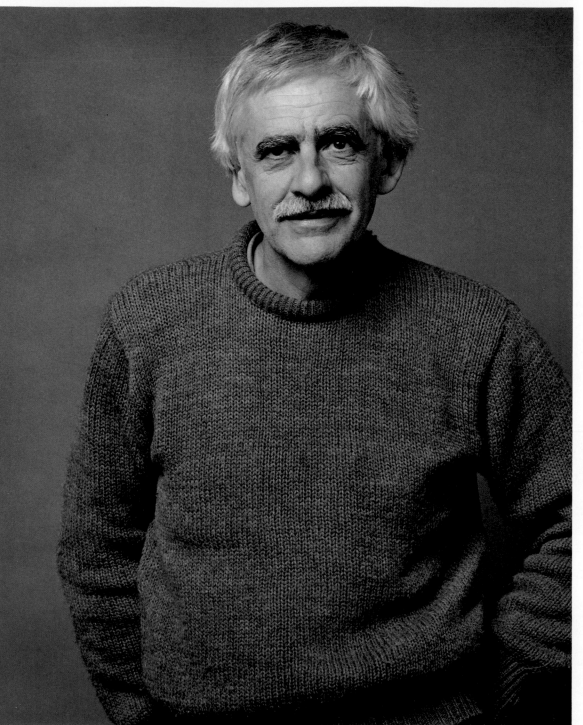

Lee Kelly

I usually work every day.

I hike in the Northwest and trek in Nepal.

I continue to live in the Northwest for reasons I am not sure of. However, I would probably continue to work wherever I lived, but of course the work would look different.

My aim in making sculpture is to continue to develop a vocabulary of forms and space relationships using metals and standard welding procedures. To me, sculpture is an alternative architecture: structures made from posts, lintels, arches, screens, and so on. I am interested in architecture of diverse cultures, and the processes of American industry.

*Akbar's Garden* · fabricated stainless steel · 1982 · 95″ by 89″ by 74″

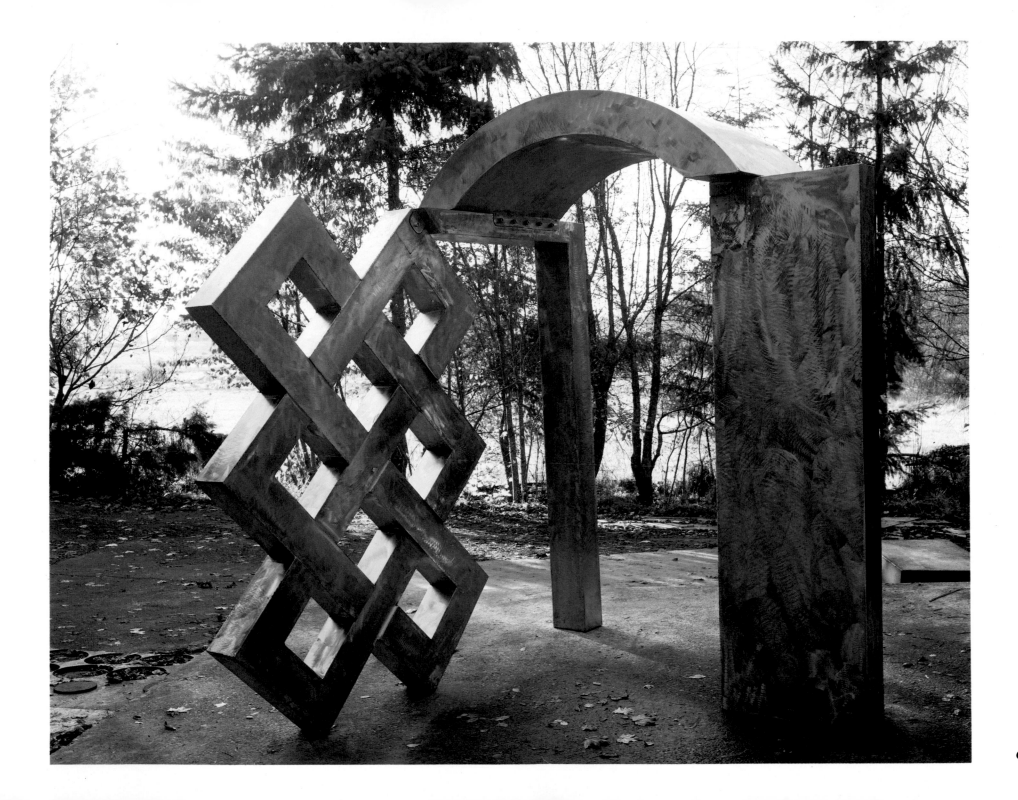

I came to art with a rural sensibility, some manual skills, and a modest knowledge of how the world works. Nancy came to art from a working court reporter's background but, additionally, with a sensitive eye and a natural creative interest. She has labored beside me these past eleven years, exchanging ideas, making decisions, painting figures, managing homes, designing catalogs, and all the while maintaining a complete photo file chronology.

My life and my art have been enriched and incredibly fulfilled by Nancy's presence, and I wish to belatedly acknowledge that fact here.

I further feel I no longer have a man's right to signature only my name to these efforts that have been produced by both of us. Hence, as of "The Kienholz Women" exhibition at Gallery Maeght, Zurich, in 1981, our work is by Edward Kienholz and Nancy Reddin Kienholz and is so signed.

*In Peace, Edward Kienholz*

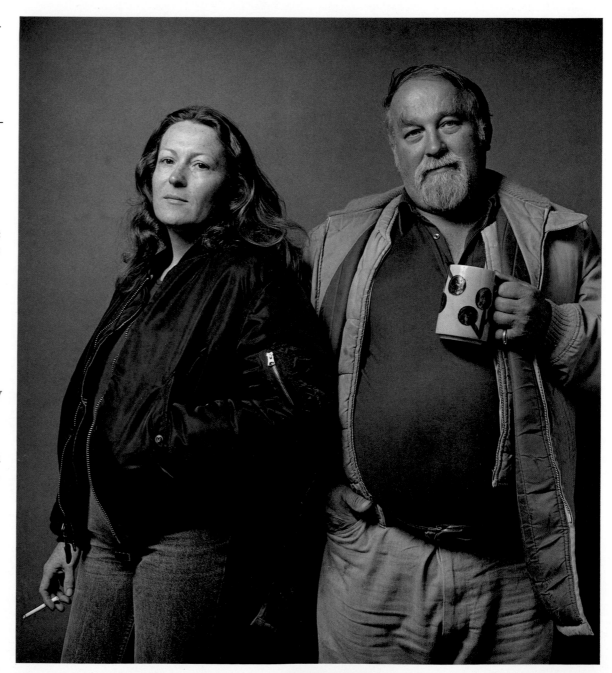

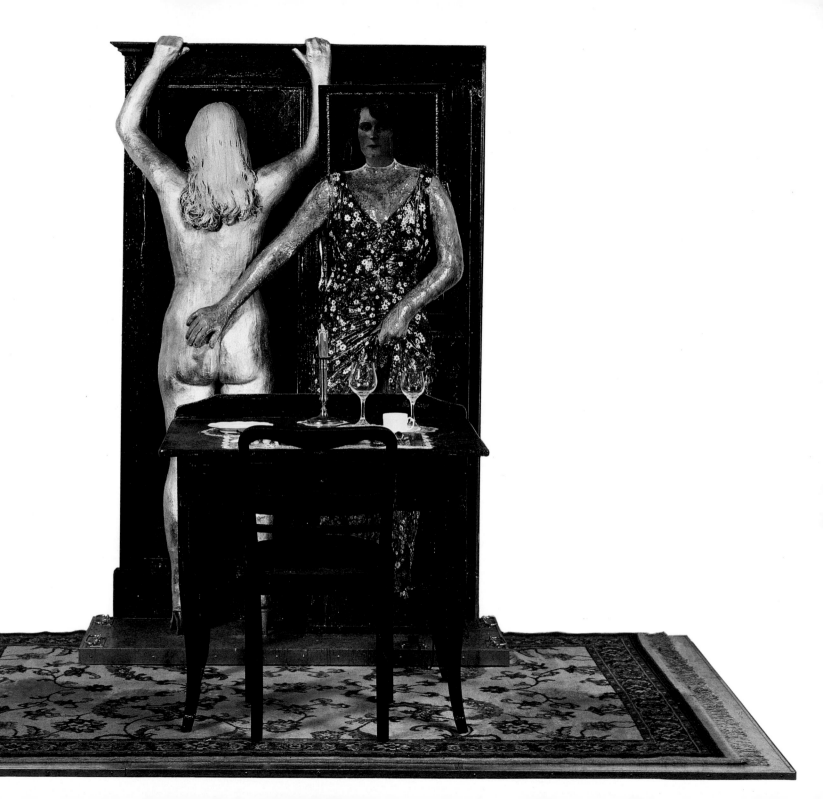

*The Queen of the Maybe Day Parade* symbolizes the typical role of the woman as wife. The two figures represent one woman. The figure facing the viewer is the wife. The table is nicely set for one (her husband), and behind it she stands passively, holding up her dress, expressing her sexual submission. On the left side of the place setting, next to the fork, is a small bronze female dog (bitch), which perhaps expresses the woman's sometimes feelings or sometimes epithet.

*The Queen of the Maybe Day Parade* is a portrait of a woman subscribing to the power of the man at the expense of her own power.

*The Queen of the Maybe Day Parade* · mixed media · 1978
80″ by 51½″ by 19¼″

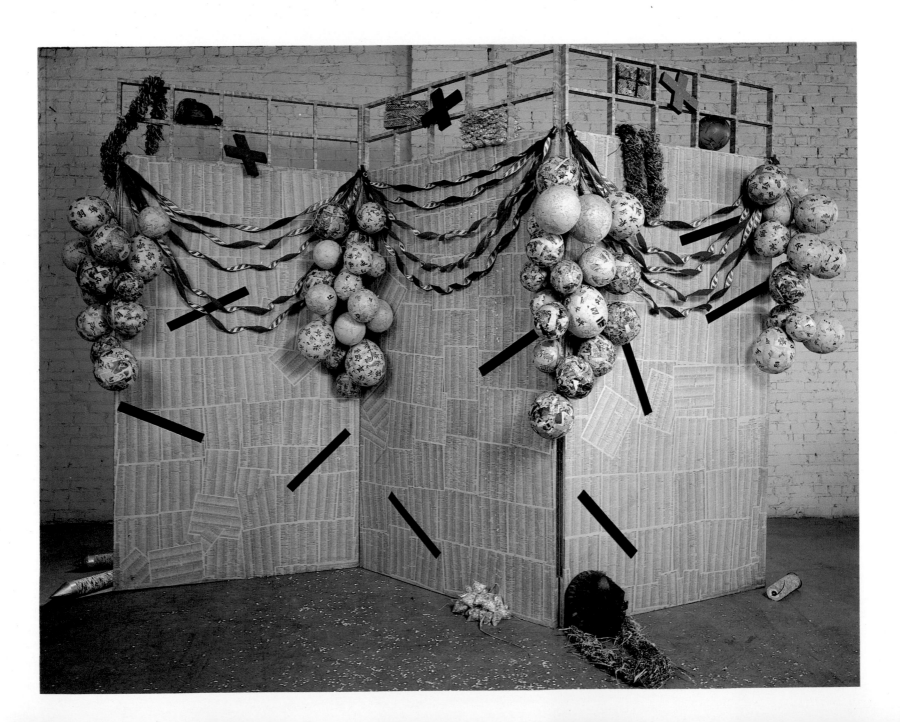

Sheila Klein

I want to dress the world.

The time of the ivory tower artist is over. It is now time to stop cutting off our ears, and instead throw ourselves into the stewpot of society to somehow fix it up.

I consider myself a catalyst or solvent.

I made my first piece in the first grade. I had a mean teacher who wouldn't let us erase. I discovered that my tennis shoes would erase the paper. Unfortunately, I got caught.

Art is a way of matching up my picture with the rest of the world. It acts as an interface between the past, present, and future.

Once when I was in San Cristobal, Mexico, I bought a serape. I was pawing through the tassels when I found parts of snaps attached to the strands. The maker had no knowledge of the use of snaps; the shiny metal represented only a glimmering ornament.

I like my stuff to act as a sensory, memory trigger.

Some time ago, I realized that a lot of art was being used as interior decorating. My response to the person who says, "It doesn't go with my couch," is "Hey, lady, I'll make you the couch."

Kleinian buzz words include: domestic situation, international furnishings, mega-girl art, native intelligence, Jewish Baroque, femme tech, what not, installerior, visual fable, attractive nuisance, portable monument, brazen and irrepentant, companion piece, climate, and playce.

*Party Set-up* is a prepared climate. The front side (shown) is the façade, which includes the guest list in the form of phone book pages, hats, gifts, confetti, horns, and assorted party paraphernalia. The rear view is the hot side of the party, the underside, the place where there are rockets and romance. So the work is recto-verso, and *mise en scène*. Some of the materials include: linoleum, wood, cardboard, rabbit skin glue, comic books, wire mesh, felt, plastic, wax, and more.

*Party Set-up* (front side) · mixed media · 1979 · 9′ by 12′ by 3′

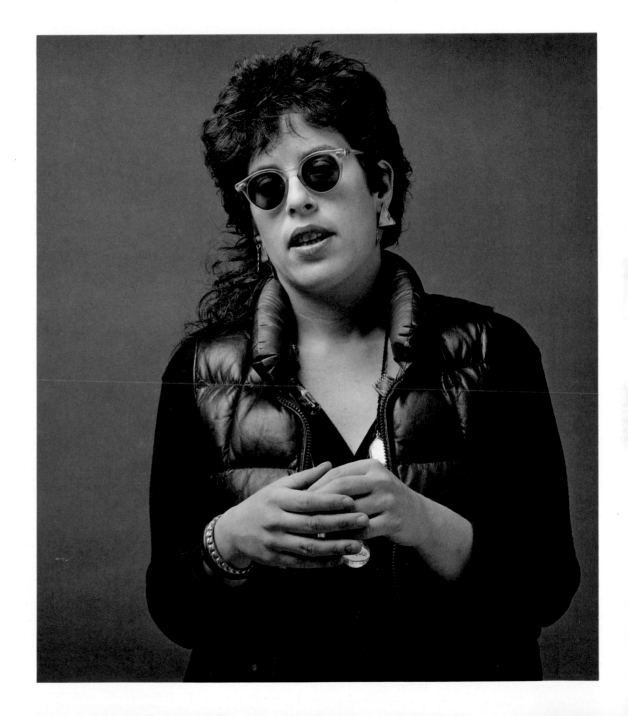

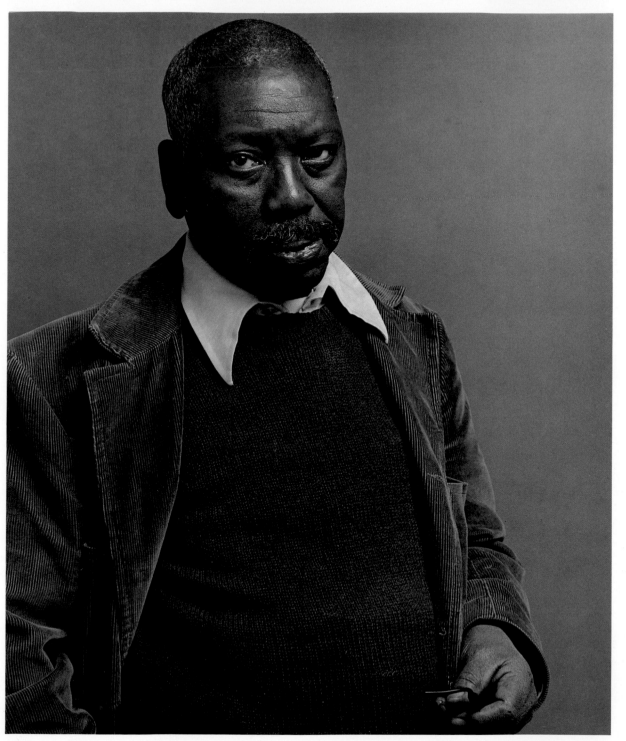

Jacob Lawrence

My first training in art (painting) took place during the Great Depression of the 1930s. I entered a federal art project center, one of many that were established throughout the country by the Roosevelt administration. It was in the Harlem Art Center that I was given materials and instruction in handling the plastic elements of line, texture, color, space, and value. My content consisted of scenes from the Harlem community: street orators, bars, churches, dance halls, vaudeville, people at work and play, and the interior of tenements. For me, the art of painting is a most magical, exciting, and rewarding experience.

This painting, *Eight Builders,* is a theme that has been repeated throughout my career as an artist. During my youth I was exposed to the various tools of a workshop. The tools, and the persons using them, were beautiful to watch. As a result, for many years I have concentrated in content on the builders theme. In formalistic terms, I have attempted to achieve the rhythm, shape, and color of tools, and the atmosphere in which people use them.

*Eight Builders* · gouache and casein on paper · 1982 · 33″ by 44¾″

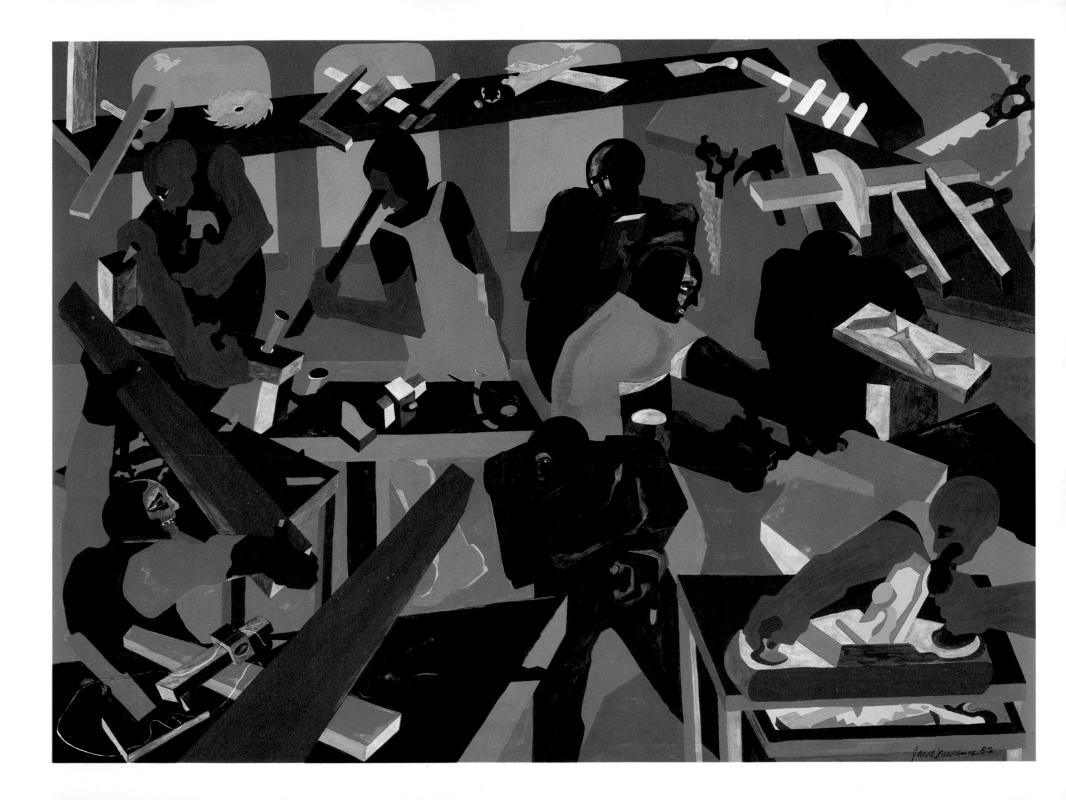

**I** was born in Los Angeles and graduated from the Art Institute of Chicago. I spent a year in Norway, where I had gone to see the work of Edvard Munch. His work, in form and concept, had considerable influence upon my painting. The influence has faded, but I still admire the work mightily.

I have spent a lot of time traveling. I've worked in London and New York. Recently, I've been to Eastern Europe, the Soviet Union, and Africa. I teach at the University of Washington for half the year, and travel the other half.

I find that Seattle is a good city for artists, though, and I intend to keep it as my base.

This drawing is one of a series in which light is the subject matter: the room is a vehicle, existing only to explain the light.

I believe that subjective, expressive content is present in my work; however, I spend most of my time with formal concerns. The other will just be there.

Norman Lundin

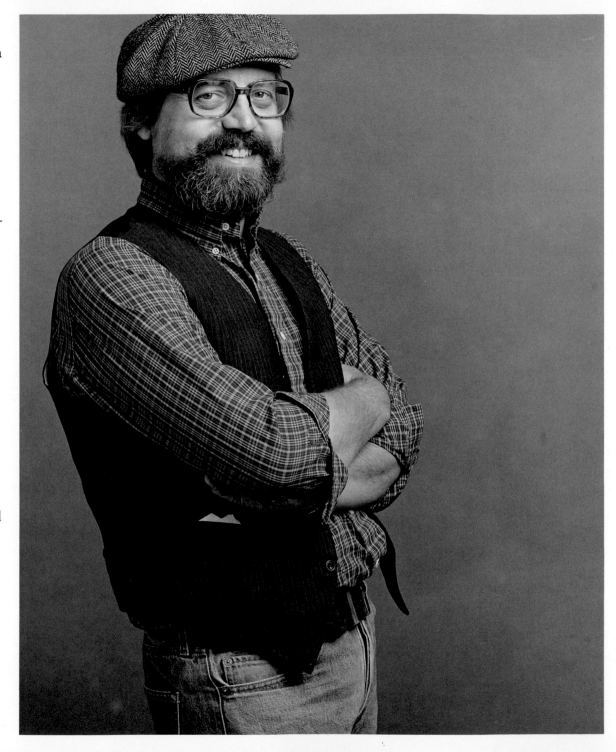

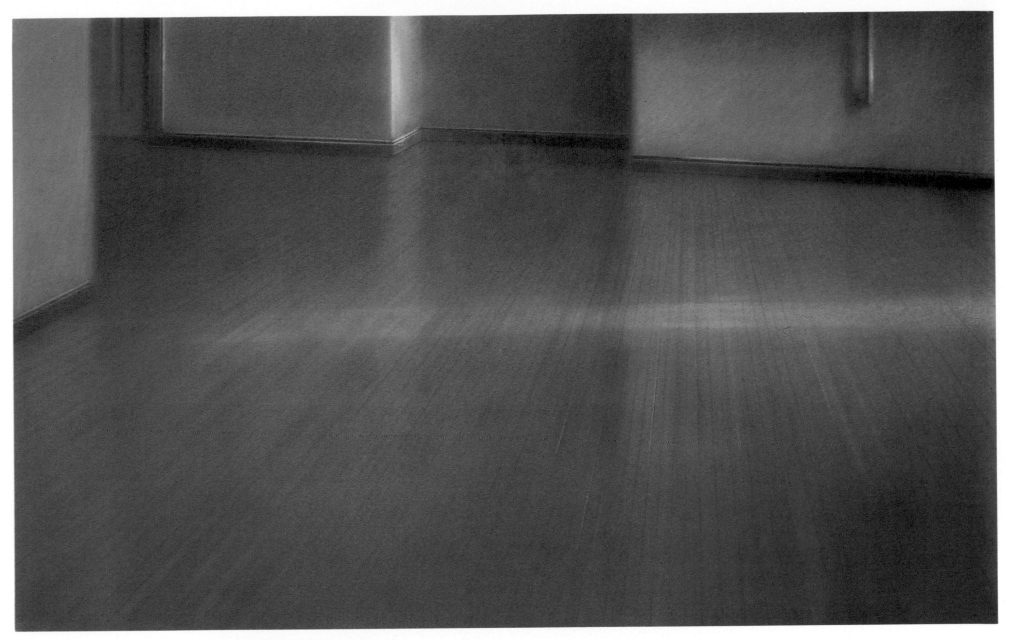

*Studio Building: Light on the Floor*
pastel on paper · 1982 · 28″
by 44″

The use of visual ambiguity developed from a combined interest in engineering drawing, perceptual psychology, and hidden image phenomena. Teaching mechanical drawing and descriptive geometry, the pictorial concepts in drafting have provided the structural frame for all my sculpture. The early wood constructions (1966) dealing with the ambiguity of line in space often paralleled floor and wall, utilizing the system of orthographic projection as implied continuation. The control of environment was further refined in the 1968 wall pieces designed to eliminate shadow. Less than one-eighth inch thick, they hugged the wall, sitting on the periphery of the space and acting as hologramlike images in a bisected sculptural space.

Incorrectly labeled as minimalist, my sculpture for the past eighteen years has involved illusionary structures and situations lending to perceptual ambiguity in both interior and large-scale outdoor concepts. I received an Endowment Fellowship in 1968 and have since maintained a separation from formal teaching, but continue participating in invitational residences involving lectures and exhibitions in conjunction with large-scale site projects. A major commission in 1972, followed by a GSA award in 1974, was preceded by a plethora of proposals and temporary mockups that have lead to numerous permanent installations. The most recently completed project, *Pentagon Square*, constructed of one-inch-thick Corten steel, is typically oriented to the site geometry without displacing space

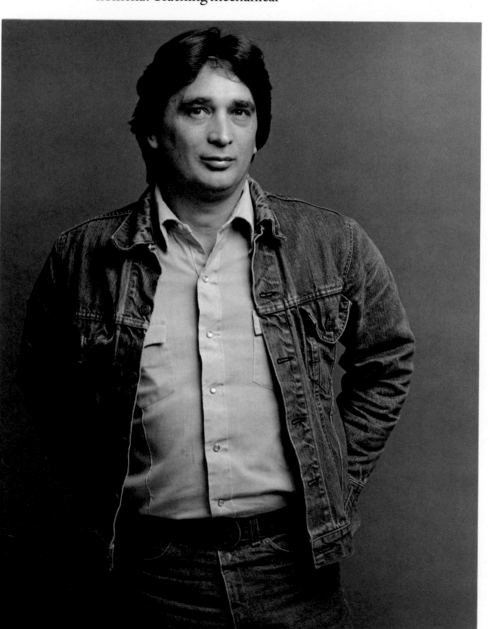

Robert Maki

and positioned to be visually restructured by shadow.

A native of Washington, I was born in Walla Walla in 1938. My family later moved to Camas, a small town along the Columbia River. I taught high school for two years after studying pre-engineering at Clark College and received a B.A. from Western Washington University in Bellingham in 1962. I completed an M.F.A. at the University of Washington and was awarded a two-year teaching appointment.

Currently living in Seattle, I've maintained the same Etruria Street studio since 1967.

*Pentagon Square* • Corten steel 1980–1981 • 66″ by 240″ by 1″

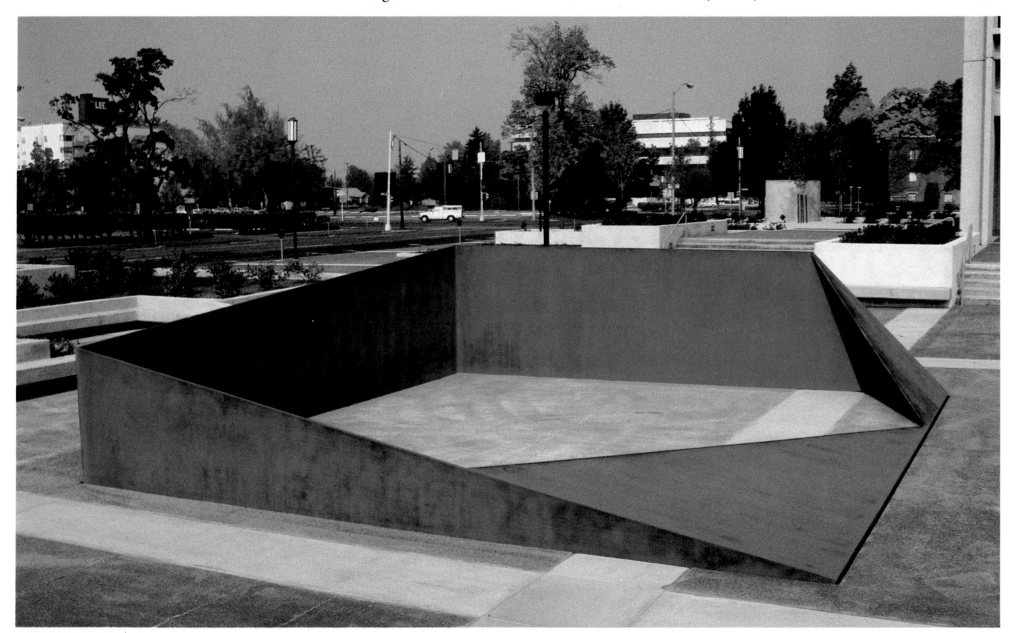

Sherry Markovitz

**I** work as hard as I can. I set no limits on how or when I work. My limit is exhaustion.

I have several strong personal influences: my family of origin, whose psychodynamics have been a continual source of reference; my partner, whose vision, optimism, and endurance keep everything in fresh perspective; and the late

*Autumn Buck* · papier-mâché, oil, beads · 1982 · 36″ by 15″ by 21″

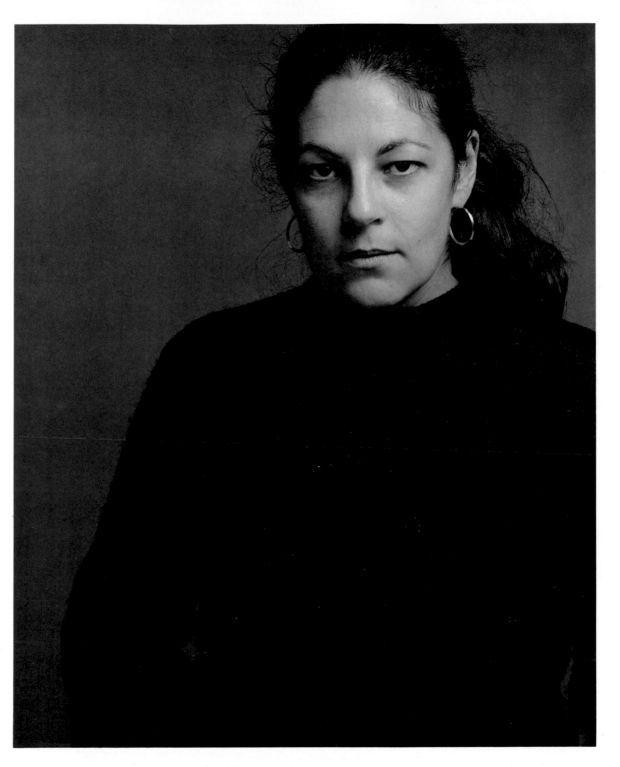

Emil Gehrke, a folk artist of Grand Coulee, Washington, who taught me that art could be about joy and totality.

Immersing myself in work and making objects is a way of setting boundaries and losing them at the same time.

I am after beauty, with an edge of uncertainty, vulnerability, and power. I use animal metaphors to explore issues of intimacy, closeness, and separation.

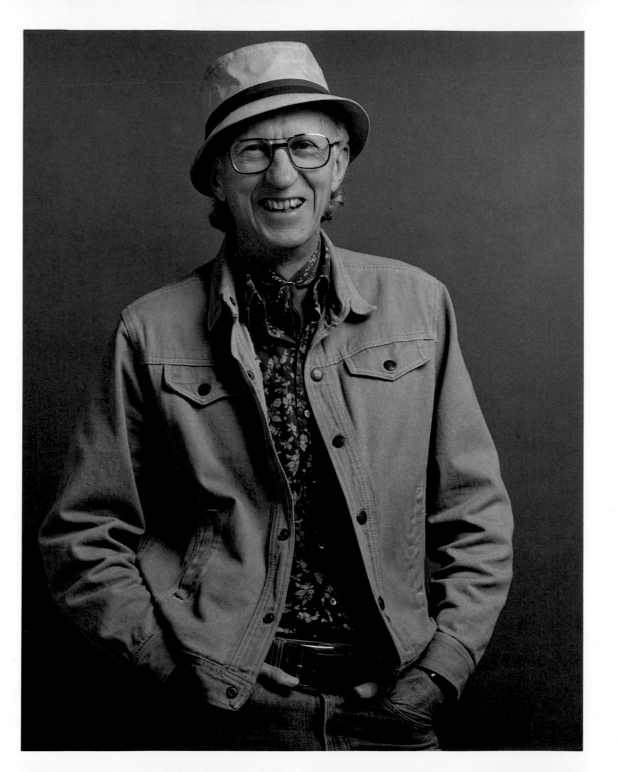

Alden Mason

I developed an interest in art while growing up on a farm north of Seattle. My earliest art experiences happened with a set of oil paints I purchased from a Sears and Roebuck catalogue, and a cartooning course I took by mail. At the time, I was more interested in ornithology, natural science, and the mystery of the natural environment than I was in painting.

Much later I went to the University of Washington and majored in entomology. I played hooky one day and visited the School of Art. I walked into a life class, and decided to change my major to art.

I like fly-fishing, bird-watching, snorkeling, dancing, and any place where the energy level is high. Bonnard,

Matisse, El Greco, and Gorky are some of my favorite painters. I have been a frequent visitor to the tropics—pre-Columbian sites in Mexico, Peru, and Ecuador. I like tribal art, folk art, and the jungle. I continue to search for that magic place that I am always sure lies just over the next hill. Maybe it really only exists in the painting.

For me, the birth of a painting is the improvisational use of energy to expressively pattern a surface with paint, which, in turn, is suggestive of the delicate balance and interrelationship of all living things in our ecosystem.

*Aunt Olga Does a War Dance*
acrylic on canvas · 1982 · 60″ by 60″

83

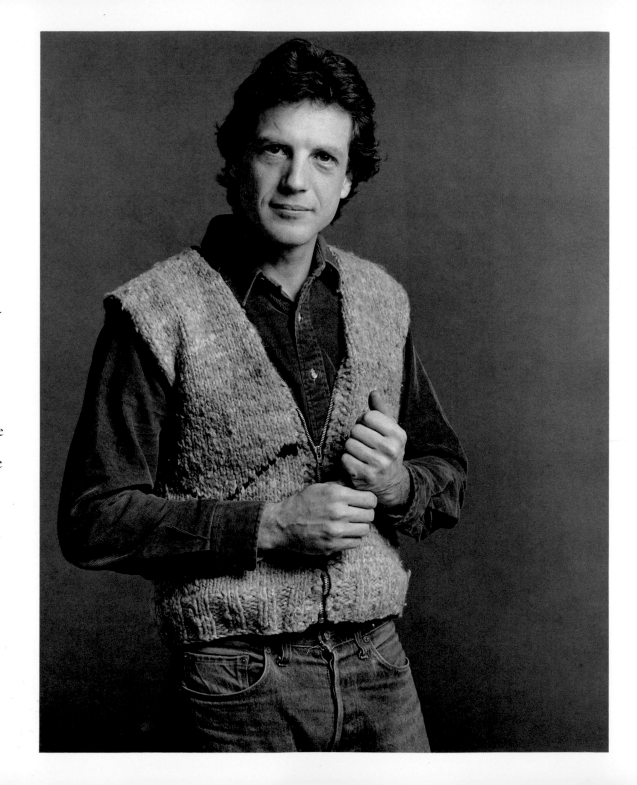

**M**y vision was really shaped by my family. My parents provided a creative and stimulating environment. They frequently dressed us up in Halloween costumes, at all times of the year.

My father, an architect, gave me a sense of scale and proportion. My mother gave me drama. I have learned much from traveling and seeing the work of other cultures.

I made this painting very large because I wanted to experiment with an environmental experience. I am not concerned with a pictorial message, but a light-space phenomenon.

Peter Millett

*Roho* · enamel on canvas · 1982
90″ by 138″

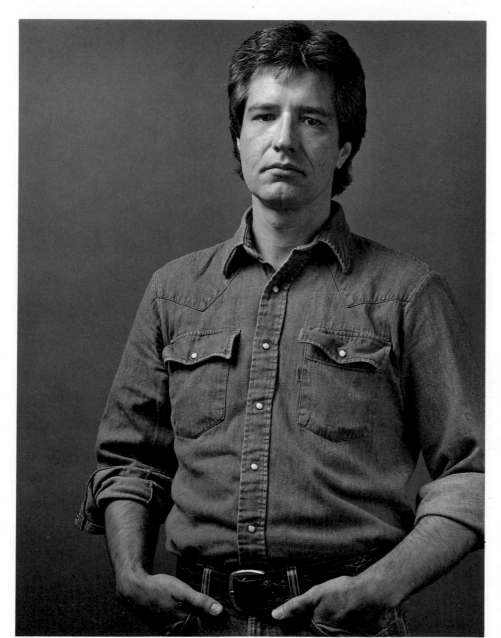

Tom Morandi

The first twenty years of my life were spent in Pittsburgh, Pennsylvania, where machines and people who act like machines are held in esteem. My disaffection with middle-class pretensions proscribed the range of my early experiences. I regard Tom Wolfe's *Kandy-Kolored Tangerine-Flake Streamlined Baby* and the film *American Graffiti* as autobiographical. However, my sculpture is not a documentary of that period, but rather a continuing attempt to refine the imagery of that ethic.

Over the last ten years, I have restrained impulse and become introspective and analytical. I moved to northeast Oregon, isolated myself from the mainstream, and sought to examine my motives objectively. Consequently, my aesthetic is narrow but deep. I evaluate visual information with the restrictive singularity of the fanatic. I retain that which is useful and discard the rest.

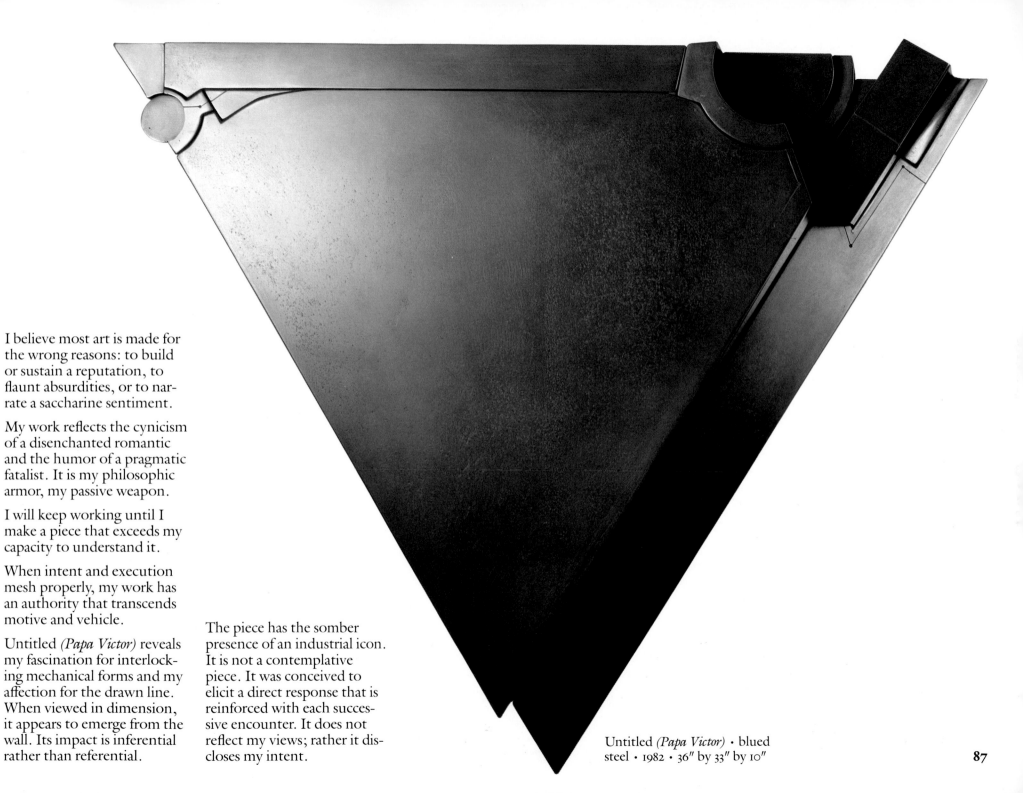

I believe most art is made for the wrong reasons: to build or sustain a reputation, to flaunt absurdities, or to narrate a saccharine sentiment.

My work reflects the cynicism of a disenchanted romantic and the humor of a pragmatic fatalist. It is my philosophic armor, my passive weapon.

I will keep working until I make a piece that exceeds my capacity to understand it.

When intent and execution mesh properly, my work has an authority that transcends motive and vehicle.

Untitled (*Papa Victor*) reveals my fascination for interlocking mechanical forms and my affection for the drawn line. When viewed in dimension, it appears to emerge from the wall. Its impact is inferential rather than referential.

The piece has the somber presence of an industrial icon. It is not a contemplative piece. It was conceived to elicit a direct response that is reinforced with each successive encounter. It does not reflect my views; rather it discloses my intent.

Untitled (*Papa Victor*) · blued steel · 1982 · 36″ by 33″ by 10″

**87**

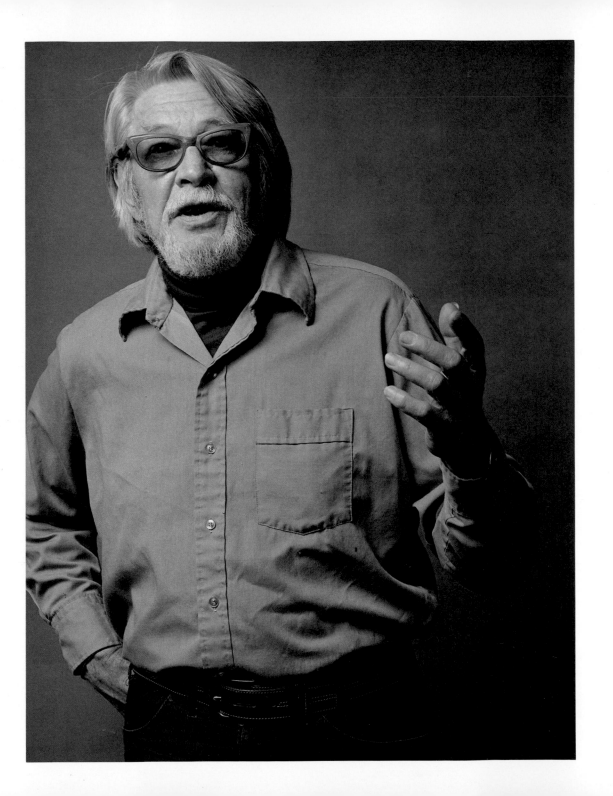

Carl Morris

To help sustain my schooling and to continue to work as an artist, I have been, at various times, a truck driver in California fruit groves, a wheelbarrow pusher on the Chicago breakwater, a superintendent of a crew of lifeboat builders, a carpenter, and a teacher.

Often, when confronting a blank canvas, the artist engages in a long and silent conversation. The idea inspires the artist; the artist creates the idea. The challenge is to make visual that which has never existed, except in the mind.

Perhaps it is fortunate that total satisfaction is never reached in a single canvas, for each one spawns another and the search goes on.

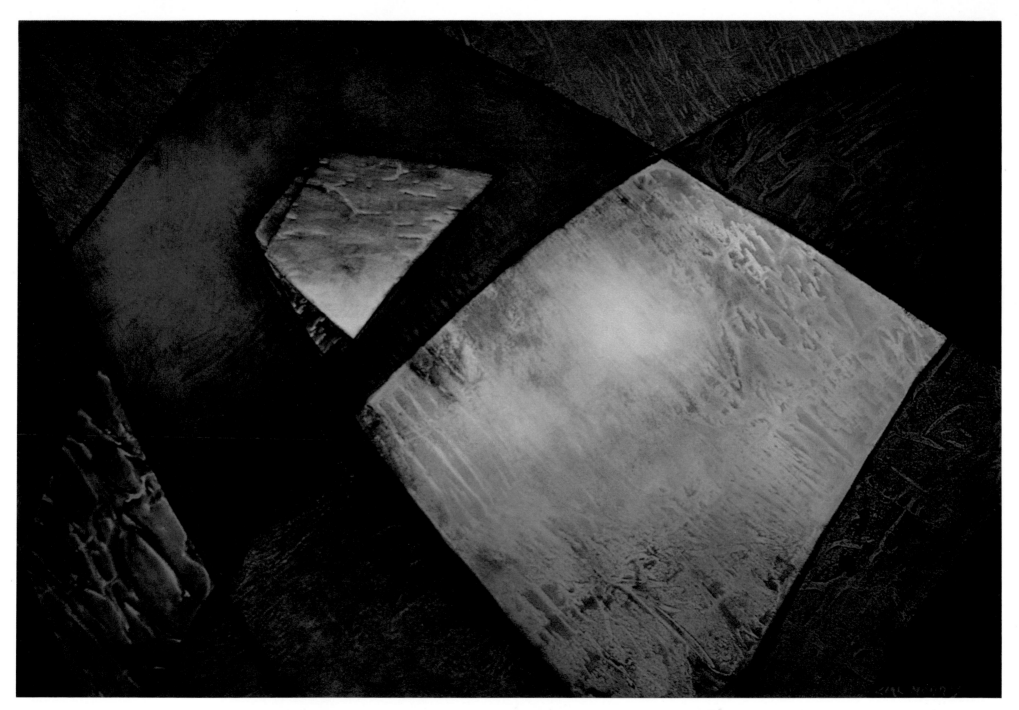

Untitled · acrylic on canvas
1982 · 60″ by 90″

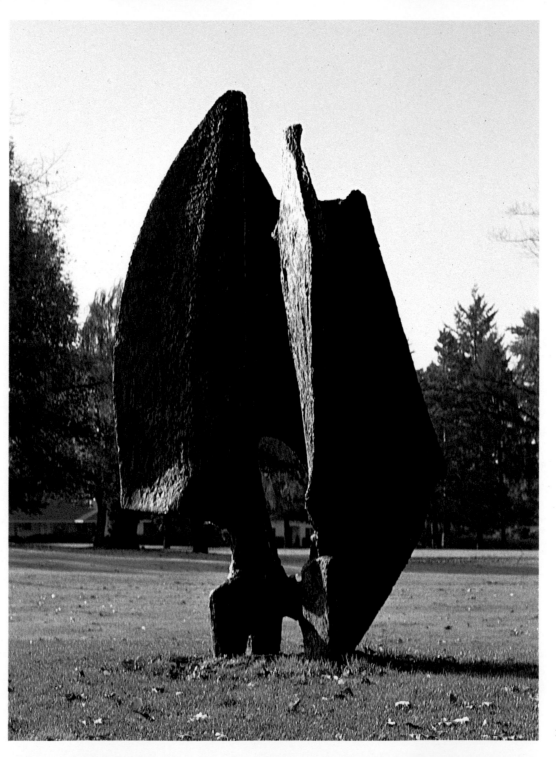

Hilda Morris

*Wind Gate* · bronze · 1980
12′ high

Recently someone asked what led me to abstraction in sculpture. In retrospect I realize that it was the reverse; it was abstraction that led me to sculpture. Neither a painter nor a sculptor, it was my high school math teacher who talked about mathematics as a means of learning about the universe. Almost pleading with us to understand that it was not just the finding of a square root of something, or as the makers of graphs would have it, but that mathematics was a form of imagery, symbols, steps, and layers in thinking, through which one could discover that which is there but not yet discovered.

I grew up in Seattle. When I was a freshman in high school my father gave me the option of getting a part-time job on the weekends or going to Saturday art classes. I took the art classes. For four years I studied with Leon Derbyshire. By the end of that period, the pattern of working in a studio had been established; I didn't have to decide to become an artist. It was a natural development.

On the West Coast artists are not as caught up in the theoretical artistic issues that are discussed in many of the New York art publications. Since these issues are not immediate enough for them, artists here tend to develop paintings out of responses to their materials. At least that's how I work.

I paint almost every day. All of my work is in oil, which, because of the time it takes to dry, allows the process of painting to be a reflective activity.

Recently, I have made an effort to move away from pure color field painting, where forms are suggested, to paintings with strong structural definition. I want the forms and colors to protrude more and to be more aggressive.

A young artist can make dramatic changes in style or approach. A young artist has that flexibility of choice. What could look like a subtle change in an older artist's work might be a major change.

Frank Sumio Okada

*AX 14* • oil on canvas • 1982 • 55″ by 69″

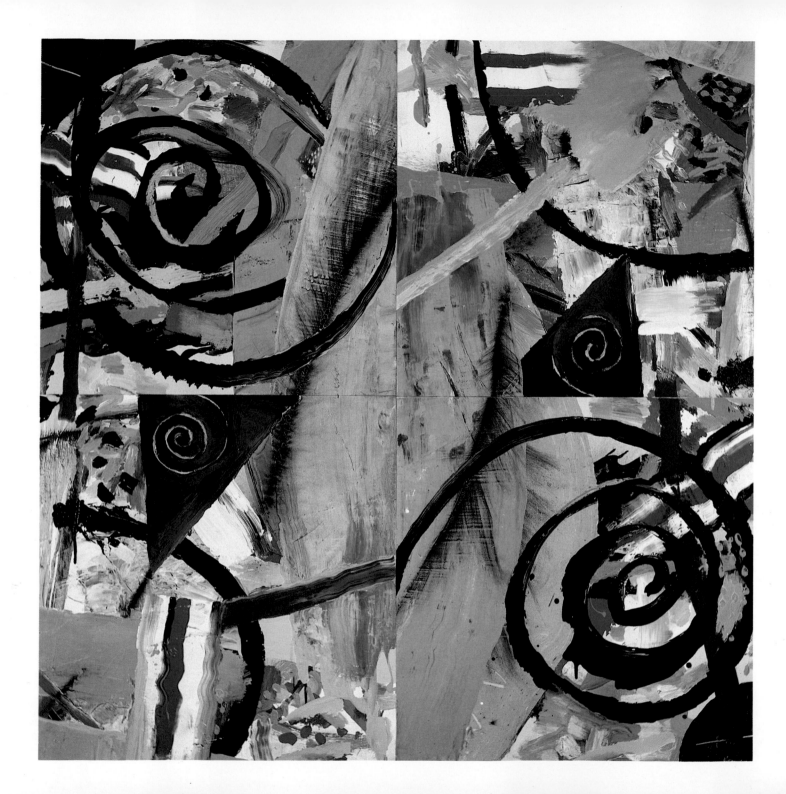

Lucinda Parker

I've been crazy about paint ever since I was a little girl. I have an early memory of standing in my family's kitchen looking down at our blue, rubber-tiled floor on which I had just dropped a gallon jar of red poster paint. The floor was an intense cerulean blue, very striking with that strong, dark, primary red splattered all over it. I don't remember my mother being angry, so I suppose the internal lesson I learned was that it's okay to mess around with paint.

In the intervening years I've had lots of great advice, support, and encouragement from a number of fine teachers; but it seems to me that when I'm in my studio I am still basically messing around with paint. There is really nothing better than moving paint across a surface, dragging a loaded brush through puddles of still wet color, overlapping one slab of paint over another.

At the same time, I am always looking for a visual structure into which I can paint freely. Usually this means some kind of a symmetrical format. Once I settle into a comfortable structure, whether it be using triangles, spirals, stars, or some jumble of all three, I find myself able to paint the same image over and over and over.

*Eve's Domain* is one of such a series. I suppose it is the combination of decorative structure and juicy surface that appeals to me. The predominating spirals might be said to signify female force, growth, evolution—all that serious stuff. Then again, they might just be damn fun to paint.

*Eve's Domain* · acrylic, rhoplex, and graphite on canvas · 1982
60″ by 60″

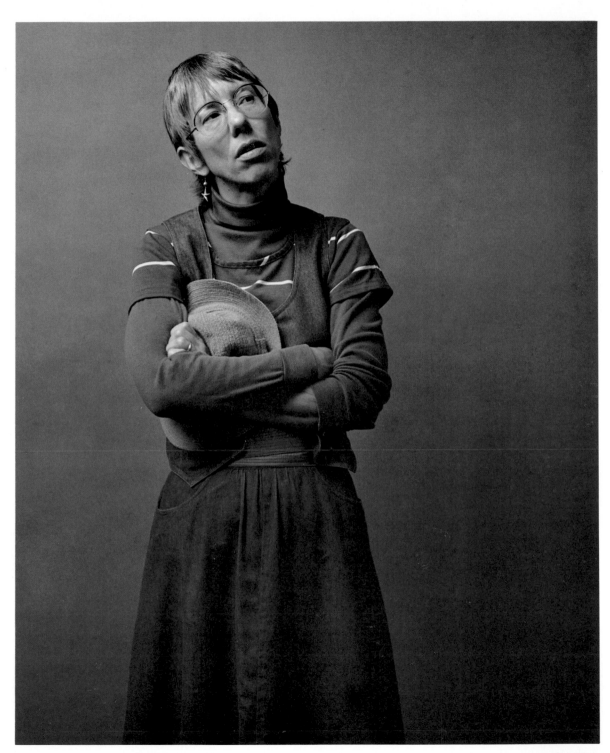

**T**rying to conjure up beginnings, I realize that any initial exposure to art, as I now understand it, had very little to do with the standard museum/gallery arena, where most encounters occur. Not being a part of my family's interests, art (culture) translated more for me as phenomena: events, places, things that left me with a sense of wonder. The geology tables at the Griffith Observatory, elaborate iconography in religious texts, mud, the frames on *Pinky* and *Blue Boy,* the salt flats at my father's project in Baja California, the Watts Towers, Carlsbad Caverns.

Mary Ann Peters

These recollections eventually collide with the uproar over Edward Kienholz's *'49 Dodge* and the "Art and Technology" show at the Los Angeles County Museum of Art, which not only triggered my awareness of "art" as a phenomenon, but also as a resource whereby awe and confusion share equal time. These memories hold as a barrage of paradoxes suspended in an instant (art), and they leave me assured that this comment should be less about answers and more about clues: an acknowledgment that the circumstances of discovery may never be refined.

I want my work to address a sense of place misplaced—symbols locked in ambiguous spaces, timeworn yet active—archaelogical dreams in contemporary settings, part fact, part fiction. My images include sources from my immediate environment, but most recently incorporate experiences encountered from my travels in non-Western countries. I believe that once beyond one's own culture, what we see and integrate is initially abstract, founded in incomplete information and committed to memory in fragments. To lend credence to these experiences within a quandary of unknowns, imagination is given precedence over the missing facts. *Veil of the Siren, Disguise of the Mime (Genesis)* is, for me, one visualization of this interchange.

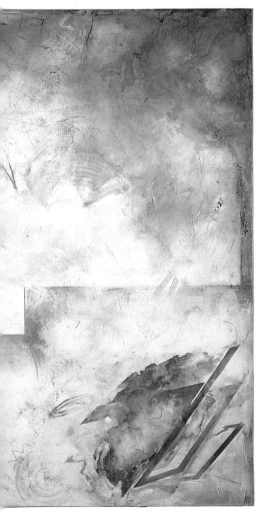

*Veil of the Siren, Disguise of the Mime (Genesis)* • dry pigment on plaster • 1982 • 96" by 204"

Jack Portland

I was raised in southern California. My earliest recollections are the colors and the heat of the desert, which I think has a lot to do with my color preferences. When I was about five, my family moved to San Francisco. I was interested in drawing and painting and so I took Saturday art classes at the de Young Museum. When we moved back to southern California, I took private lessons and worked on my own until high school. A high school counselor discouraged me from taking any art classes and I drifted away from making any art.

In college I majored in Spanish and Spanish literature. Two friends rekindled my interest in painting. I took a couple of introductory classes, but knew that I needed to go to a different school. My family had moved to Oregon by then, and when I visited them one Christmas I found out about the Museum Art School in Portland.

I started there in 1967. I fell in love with the Oregon landscape, and now I think that the interiors here have influenced my compositions and are a source for the forms I use. The landscape in the Northwest has a dense, complex, claustrophobic feeling that intrigues me.

Here I've met most of the people who have had a marked impact on my personality, painting, and career. Arlene Schnitzer, Louis Bunce, and my wife, Suzanne Duryea, have had an enormous influence on me.

This painting was done in early summer, 1982. I don't make very large paintings. Four-by-six-foot paintings are the largest. This is one of the largest nearly square paintings. The scale and format presented problems I hadn't encountered before.

The circle motif with the organic forms in and around it, while not new in my work, took on more importance in this painting. It became the subject matter. I don't work from preliminary drawings, and I don't remove or scrape paint from the paintings. Painting, for me, is always a building process. Some areas, the thin areas, are obviously less worked and become the constants in the painting process. Other areas, the thicker ones, are layer upon layer of color changes. The thick-thin physical textures change from painting to painting, depending on how long it takes me to solve the painting.

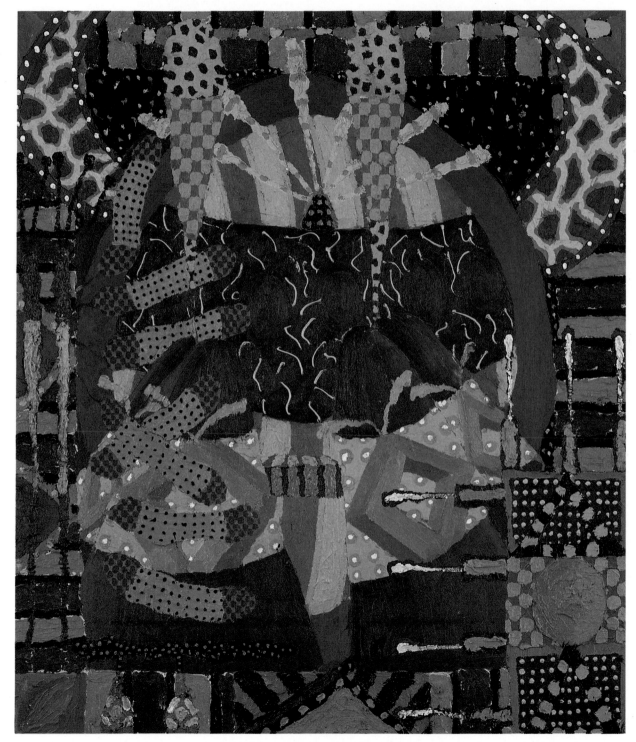

*10 C Halycon* • oil and wax on canvas • 1982 • 49″ by 42″

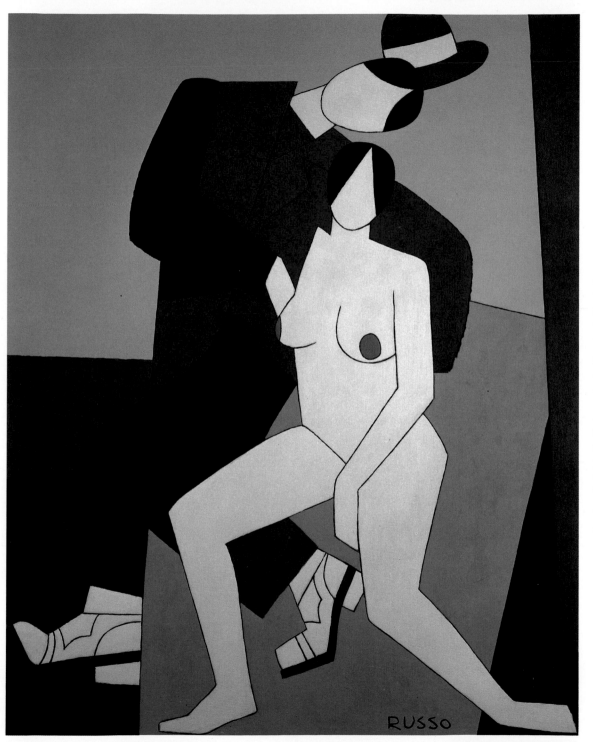

*As with Affection* · oil on canvas
1982 · 59″ by 49″

Michele Russo

I was born a long time ago somewhere back East. I was raised in several places and did not speak English until I was ten. Legend has it that I was introduced to art as a child. I have youthful memories of desires to escape the consequences.

At twenty, I dropped out of my living world to study art on a campus under the most negative circumstances, without money and in an ambience charged with ignorance and hostility toward modern art.

In spite of this I finally earned a B.F.A., and so was of that generation that sought art through accreditation. I owe my education to many people, mostly immigrant ethnic friends of my childhood—anarchistic Italians, revolutionary Lithuanians, Russians, and Jews who guided me lovingly and thoughtfully through my youth. The Depression of the 1930s completed my education as an activist. The Depression, war, and fascism were the background against which I viewed the objective world. My educational experience would not have been complete without Boardman Robinson, with whom I enjoyed a fellowship at Colorado Springs.

I married a painter who enriched my life emotionally and intellectually, with love and conflict. I have been teaching and painting all my life.

I chose to become a Northwest painter when I settled in Portland in 1947. I found here a favorable environment where I could be free from the "aesthetic" successes that obsess contemporary artists. I like to travel when possible, which gives me relief from the chauvinistic substance of our culture.

*As with Affection* belongs to a cycle I have worked on titled *Mockeries and Ecstasies on a Chauvinistic Theme*.

My taste in art is universal and willful depending on where my searching mind takes me.

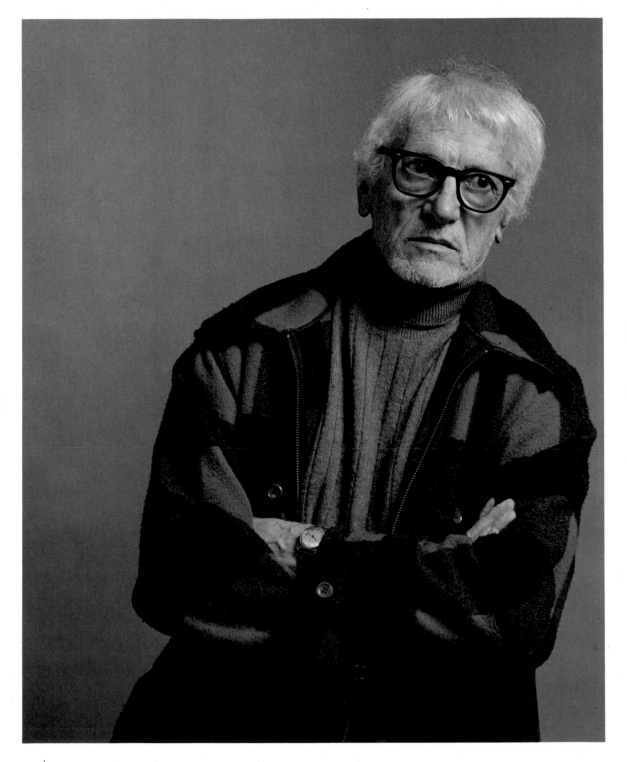

Thirty times each second, 525 lines of phosphors light up and fade, not all lines at one time, but one line at a time, one phosphor at a time. This is the event of the video image. Only one phosphor is actually lit fully at any particular moment and the image we actually perceive is a mostly fading, decaying one. It is an intangible image, never present in its full luminosity. And, because this is a phenomenon of light and electronics, the image is really never physically existent at all. Video and television inject an order into the way those phosphors react. Although some may wish to create reality through television and some viewers might confuse reality with what happens on the screen, the only "real" thing that happens is that these phosphors light up in a certain pattern. This is an important source for my work.

I look at the phenomenon of video from its basic elements of the phosphorescent screen and the fading image that happens too rapidly for our eyes to perceive. The potential for order is more important almost than how the order finally takes place. Working both in video (tapes and installation/sculpture) and on static paper, I examine the various phenomena that occur on the screen. I'm interested in that which we don't often pay attention to: the electronic "junk" that engineers spend so much time removing from our video experience. I like to recreate it in video through non-electronic elements in front of the video camera. I like to capture a moment, ordinarily unseen by our slowly reacting eyes, onto

Norie Sato

*Evidence: Electronic Event I*
mixed media on paper • 1982
34⅛″ by 65½″

paper. A fellow artist, Bill Ritchie, made a videotape called *Things You Can't See*, which I sometimes think about when describing my work. Though his tape and my work are not actually related, other than conceptually through the title, I work with those things one doesn't usually see, but might glance or perceive faintly, those mementos of electronic events. All the elements are there, though perhaps not immediately apparent. Look closely.

Buster Simpson

Balanced elements sited
   along the fence stake

Pivoting at the fulcrum
   aligning to changing winds

One windvane counters the
   other's adjustments

Surveyor Sights   Counter-
   balanced Crowbar
Fencestake Tripod   Fulcrum
   Pivotpoint
Crystal (Ballast) Plumb bob.

Earlier prototypes sited at:

Artpark, Lewiston, New
York, 1978: portable prop
atop toxin spoils pile.

Viewland Hoffman Receiving
Substation, 1976 to present:
workman decoy/design team
process prop.

*Surveyor Counterbalanced Crowbar*
aluminum, steel, wood, plastic,
glass, water, wind · 1980 · 72″
high by 88″ radius (windvane)

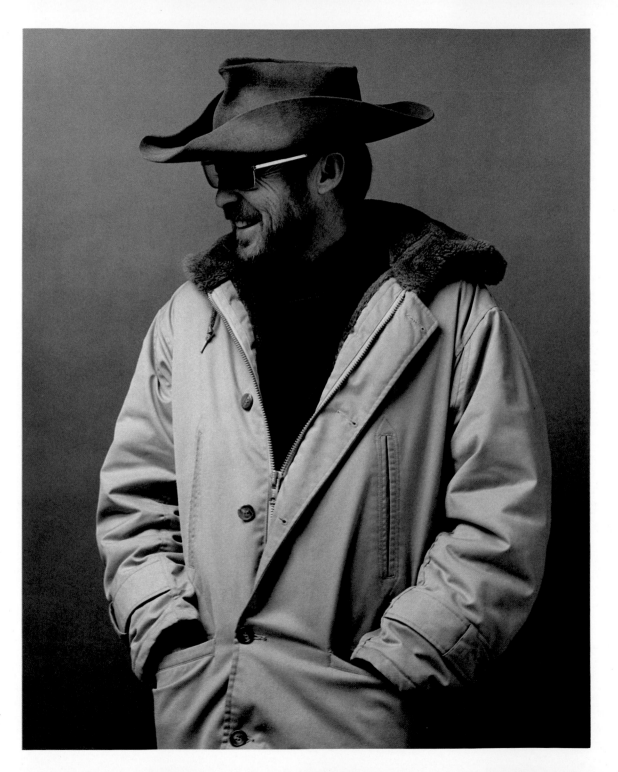

Michael Spafford

**I** have been encouraged and aided by many people during my career as a painter. My mother first expressed appreciation for my efforts to make pictures, and by the time I had graduated from Pomona College in 1959, the difference between making pictures and painting had become clear to me.

My interest in art was stimulated by my studies of art history, philosophy, and classics. My interests in painting were stimulated by the work of the abstract expressionists, the German expressionists, and Mondrian. A class in early Netherlandish painting, taught with singular intensity and wonderful intelligence by the art historian and artist Teresa Zezzos Fulton, had a great impact on my emerging visual sensibilities.

After receiving an M.A. in art history at Harvard, I spent three years in Mexico City, where I painted full-time and exhibited. It was there that I solidified my personal interest in figurative expressionism and developed an abhorrence for facility. It was there that I read Yeats and painted Leda and the Swan for the first time in 1961.

My interest in mythology as a visual framework for thought and feeling was intensified by the two years I spent as a Fellow of the American Academy in Rome, from 1967 to 1969. Dualism, metamorphosis, the confrontation of opposites, the struggle for achievement, the ultimate failure of an heroic effort —each of these gestures is expressed in the myths I use. My effort is to translate these gestures into abstract visual terms and pass their energy on to the viewer.

The painting *Leda and the Swan* evolved from multiple variations on the same canvas over an extended period of time until the simplest visual elements of attraction and opposition could be realized. I have never been able to get a painting right the first time.

It has been my great pleasure to teach painting and drawing at the University of Washington since moving to Seattle in 1963.

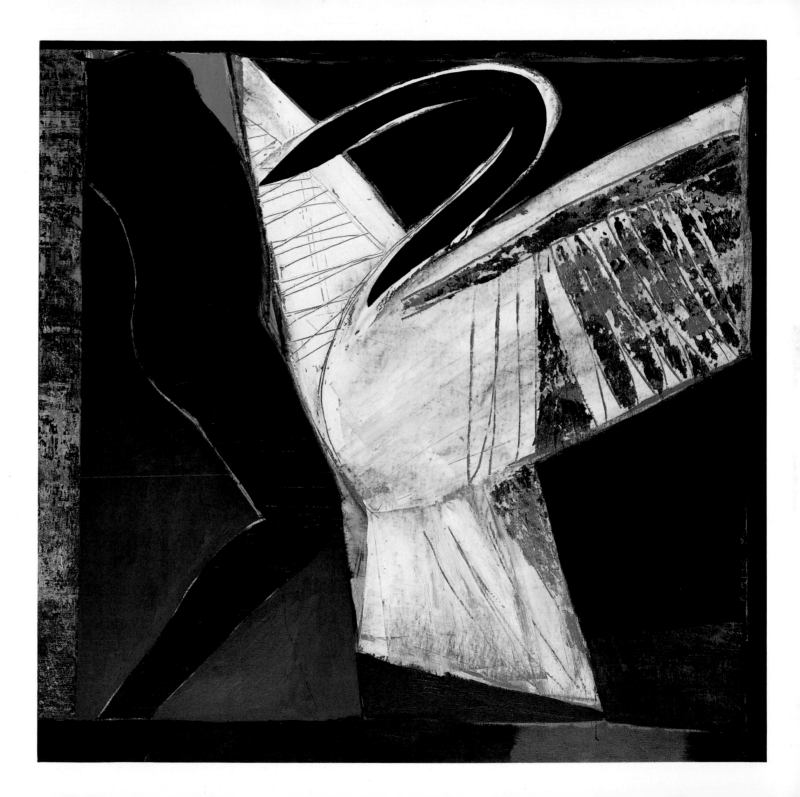

*Leda and the Swan* · oil on canvas
1982 · 72″ by 73″

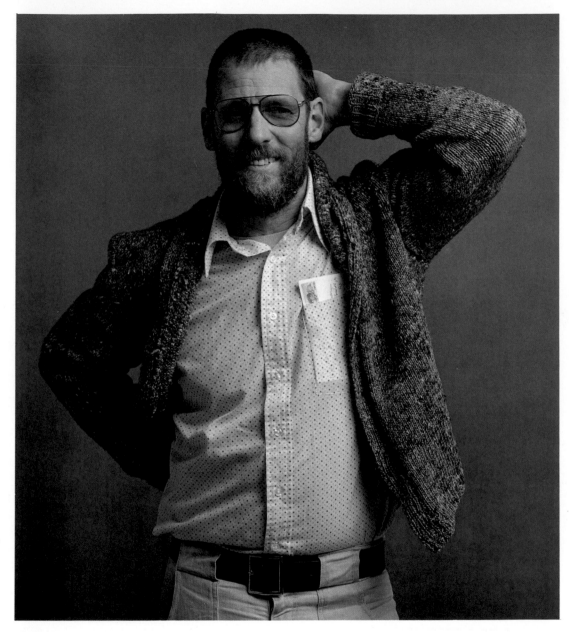

Peter Teneau

Art provides a context for dealing simultaneously with what I know and would like to know.

At present my approach is a response to three main questions: First, what relationships or forces, what order, underlie appearance? The determinants of what we perceive, such as change, systems, and processes of transformation (as expressed in nature, for example) interest me.

Second, how can I create a means for the organization of an artwork to evolve on its own? In some recent pieces I have been working with various kinds of ordering procedures that are set up to determine specific aspects of the composition, such as the scaling of part size, color, spacing, curvature, and angular changes. Complexity grows as a function of intersecting orders. The piece flows out of this process. I discover it more than compose it.

Finally, how does the artwork relate to the location? To me, site is the given situation, the environment, a comprehensive mixture of space, the activity within and around it, light, physical features, expectations, movement, etc. A site may generate unique ideas. It certainly influences the ideas I bring to it.

In practice, for each piece, the three questions are answered together. My output has thus taken various forms: permanent or temporary environments, constructions, assemblies, reliefs, and kinetic works involving motion, sound, and light. In general, the pieces have been very large, occupying rooms or outdoor areas.

Often I attempt to engage space as an active component of the work. My choice of materials and technique has ranged from simple laminated wood-strip constructions to high-precision metal fabrication, integrated circuitry, and solar power.

The space *Delta III* occupies is an eighty-foot-high, twenty-foot-wide, four-foot-deep shaft contiguous to a stairway. The site conditions suggested linear development and open form. This stimulated a personal interest in the manipulation of number series as a means of achieving a form of self-generating composition.

Technically, the piece is a product of the flexible application of combined, experimentally derived mathematical and graphic methods. One order creates a serial connection between post size, location, and interval. A second order is used to derive the spacing and angle of each of the 136 cables that form the three-

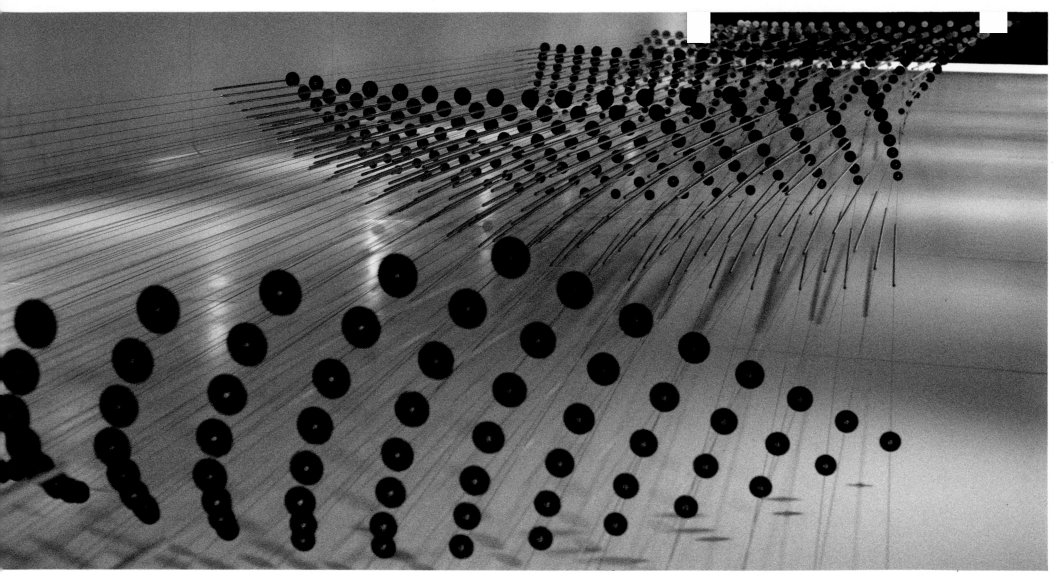

dimensional field. A third order determines the routing of the first order series through the second order matrix. The configuration, as it appears, evolves naturally out of the dynamic interaction of these procedures.

The work is intended to be seen at various levels as one moves through staircase areas. A companion piece, varying in appearance but resulting from the same approach, occupies an identical stairwell area in the same building.

*Delta III* · polished and painted aluminum posts on stainless steel wire · 1982 · 80′ by 20′ by 4′

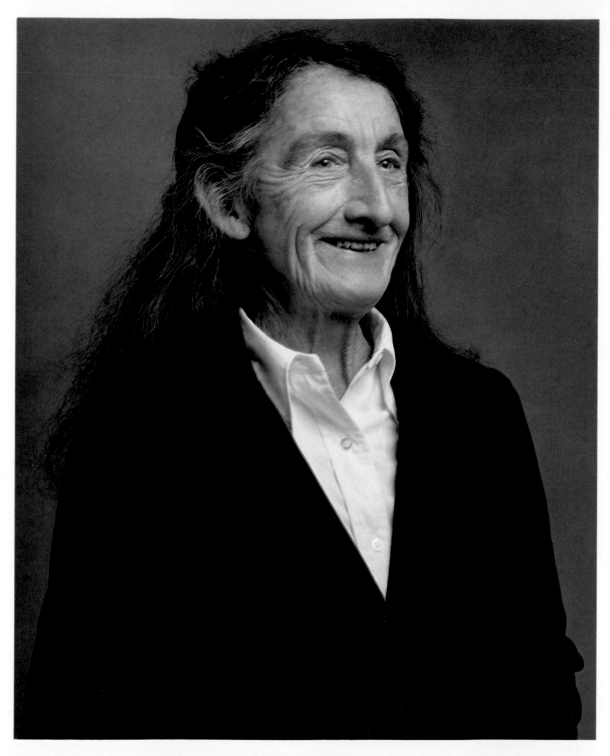

Margaret Tomkins

I was born in Los Angeles, California, and became a citizen of the Northwest in 1940. Painting was a strong part of my life since early childhood; it has remained a dominant force. The family was supportive of art. My grandfather painted landscape scenes on the sides of passenger trains going west to California in the 1890s, and easel paintings. My father was a part-time artist and my mother was a pianist.

After receiving an M.F.A. at the University of Southern California, I was appointed to the art faculty of the University of Washington for 1939–1940. Remaining in the Northwest, I married the painter/sculptor James FitzGerald and worked in a Seattle studio along with our three children (two artists, and one a poet). My paintings were made in independent isolation in the city and at the rock, timber, and glass studio we constructed in 1948 in the San Juan Islands, where I now paint.

The Northwest in the 1940s and 1950s was a dead end for the exhibition of strong, abstract paintings produced nationally or regionally. The focus was on a so-called "mystical art" or regional realism. Modern art shows at the Seattle Art Museum and the few galleries in the Northwest

were minimal in number and quality.

Escape artists chose to exhibit work at East Coast museums. The recent decades have opened a new Northwest passage of freedom and independence for the artist, with unique, more personal statements dominating exhibitions.

The span of my life work moved from the early egg tempera paintings that revealed an abstract metamorphosis of man and nature, to the large oils of the 1960s, which were energized by the tensions of line, shape, and space. In 1959 a studio fire destroyed all of my work prior to that year. After a period of European travel in 1961, I returned to painting. Since the 1970s my acrylic paintings have involved the changing substance of light, line, and color.

In my island studio, I work. The painting *Shafts* exposes my direction: I pursue shifting space and varying focus, shadows of the possible, tangents of conclusion, seasons of the mind and spirit.

Each day the sun gets up and
　　then crashes into the sea
It creates a space for anything
　　to be done
So I do it—painting.
Nights carve stars in silence
Wind-blasts shatter rain
Waves roll the shore rocks.

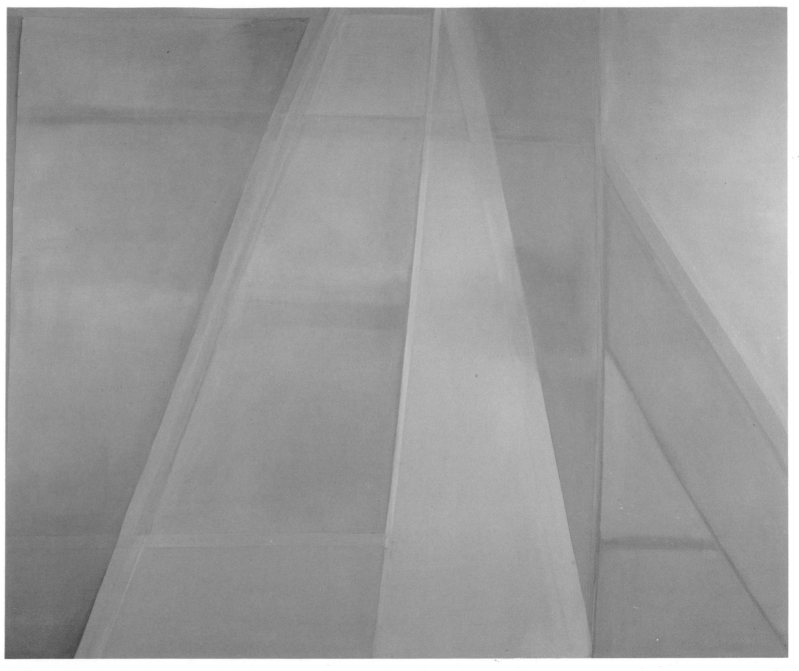

*Shafts* • acrylic on canvas • 1980
76½″ by 93″

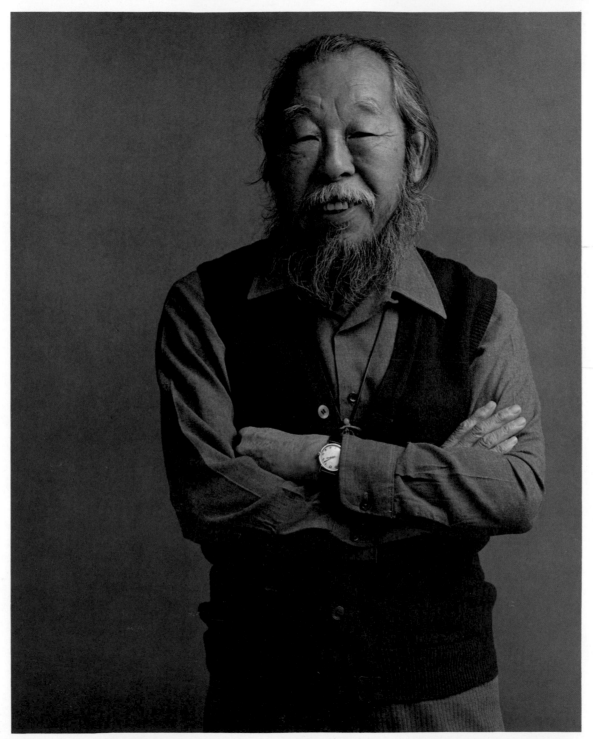

George Tsutakawa

**I** was born in Seattle on February 22, 1910. I spent ten years of my childhood in Fukuyama, a small town in western Japan. In this setting I learned to appreciate the objects and rituals of Japanese art and religion.

When I returned to Seattle in 1927 after schooling in Japan, I became an avid student of Western culture. My curiosity and enthusiasm took me through graduate work in art at the University of Washington in pursuit of the history and techniques of painting and sculpture from Giotto to Calder. Among my teachers were Alexander Archipenko, Paul Bonifas, and Mark Tobey, who greatly influenced my work and philosophy.

I taught at the University of Washington and had some success at exhibiting and selling my paintings and sculpture. In time, however, I became suspicious of the Western world view that seemed intent on separating humans from nature and destroying nature in order to build an artificial dream world. I suspected that modern abstract art reflected this attitude.

In about 1960 I became aware once again of the Eastern philosophy and art of my youth—and Japanese art in particular. Through travel and study of traditional Japanese art, I was able to reconfirm my belief in the Eastern attitude toward nature, which is that humans should be part of nature and live harmoniously with it.

I have traveled extensively to many parts of the world, but I enjoy most of all living in the Pacific Northwest surrounded by my family and a breathtaking natural environment.

In my work since about 1960, I have attempted to reflect a positive relationship between humans and nature. My sumi paintings are my direct response to nature, and my fountains are an attempt to marry permanent metal sculpture with the elusive and naturally recycling water, which is a life force in our universe.

*Song of the Forest* • bronze • 1981
20′ high

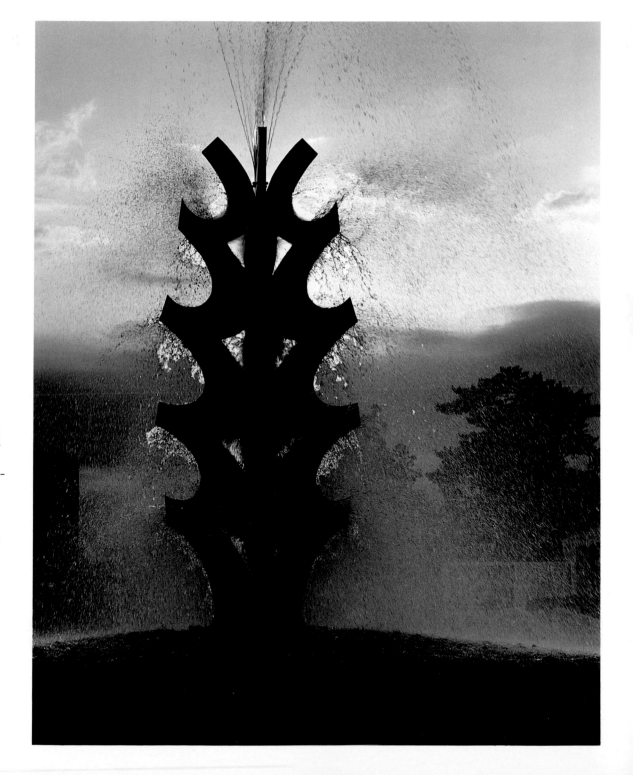

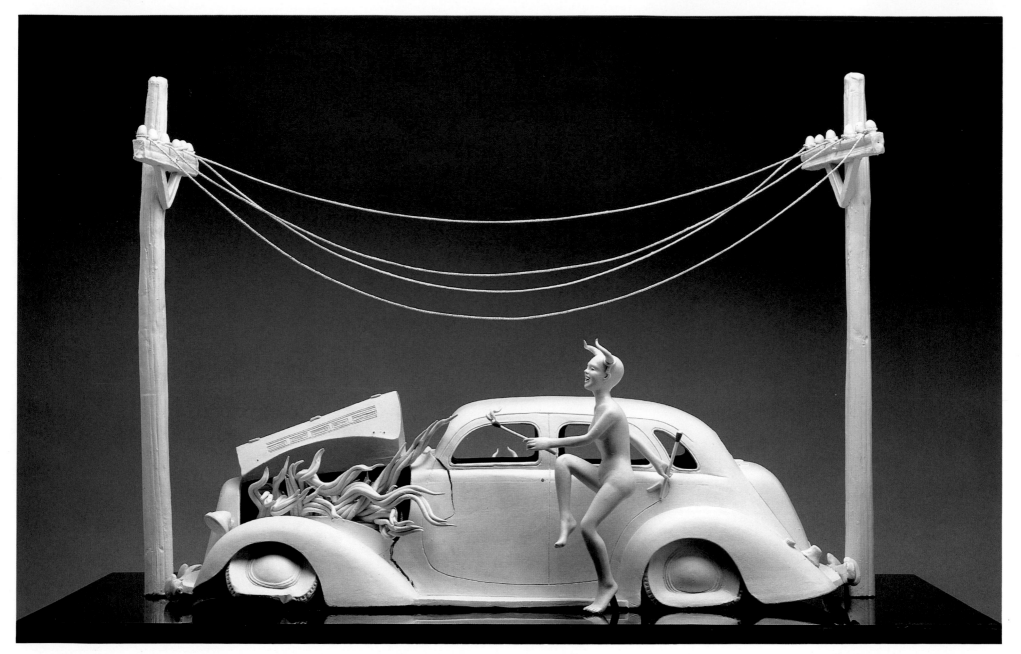

*High Tension Wire* · clay and mixed media · 1982 · 31″ by 39″ by 22″

Patti Warashina

My art is a visual journal of only a part of my life. As a child I collected dolls, dreams, and fantasies. I feel lucky that my work involves translating those collective observations from my psyche into a tangible form, which I may or may not comprehend.

Sometimes the fascination of the unknown is overwhelming, and electrifying. It is a mystery to me why I'm compulsive about continuing this "making of art," but I find that to keep peace of mind, it has become as necessary as eating and sleeping.

I feel the same fascination with gardening. You might compare the making of art to growing a garden: is it a hit, or is it a miss? Whatever the results, there is a chance that future growing seasons will be this lifetime's journal, or a gigantic compost pile that turns back to dust.

For more information about the artists presented in this book, contact their galleries or artists' representatives; a partial list follows. The Seattle Art Museum, Modern Art Department (Volunteer Park, Seattle, WA 98112), is also a good source of information about these artists and their work.

*Guy Anderson*

Francine Seders Gallery
6701 Greenwood Avenue North
Seattle, WA 98103

*Jay Backstrand*

Jay Backstrand
4931 Northeast 33rd Avenue
Portland, OR 97211

*Jeffrey Bishop*

Linda Farris Gallery
322 2nd Avenue South
Seattle, WA 98104

Karl Bornstein Gallery
1662 12th Avenue
Santa Monica, CA 90404

*Joan Ross Bloedel*

Foster/White Gallery
311½ Occidental Avenue South
Seattle, WA 98104

Karl Bornstein Gallery
1662 12th Avenue
Santa Monica, CA 90404

The Fountain Gallery
117 Northwest 21st Avenue
Portland, OR 97209

Equinox Gallery
1525 West 8th Avenue
Vancouver, B.C.
Canada v6j 1t5

Pace Editions
32 East 57th Street
New York, NY 10022

Miriam Perlman, Inc.
Lake Point Tower Suite 5410
505 North Lake Shore Drive
Chicago, IL 60611

*John Buck*

Fuller Goldeen Gallery
228 Grant Avenue
San Francisco, CA 94108

Concord Contemporary Art
451 Broome Street
New York, NY 10013

Zolla/Lieberman Gallery
356 West Huron Street
Chicago, IL 60610

Morgan Gallery
5006 State Line Road
Shawnee Mission, KS 66205

Asher/Faure
612 North Almont Drive
Los Angeles, CA 90069

*Louis Bunce*

The Fountain Gallery
117 Northwest 21st Avenue
Portland, OR 97209

Hodges/Banks Gallery
319 1st Avenue South
Seattle, WA 98104

Eason Gallery
338 East DeVargas
Santa Fe, NM 87501

*Deborah Butterfield*

O.K. Harris Works of Art
383 West Broadway
New York, NY 10012

Zolla/Lieberman Gallery
356 West Huron Street
Chicago, IL 60610

Fuller Goldeen Gallery
228 Grant Avenue
San Francisco, CA 94108

Asher/Faure
612 North Almont Drive
Los Angeles, CA 90069

*Kenneth Callahan*

Foster/White Gallery
311½ Occidental Avenue South
Seattle, WA 98104

Kraushaar Galleries
724 5th Avenue
New York, NY 10019

*Francis Celentano*

Diane Gilson Gallery
209 Occidental Avenue South
Seattle, WA 98104

The Fountain Gallery
117 Northwest 21st Avenue
Portland, OR 97209

*Jack Chevalier*

Hodges/Banks Gallery
319 1st Avenue South
Seattle, WA 98104

The Fountain Gallery
117 Northwest 21st Avenue
Portland, OR 97209

Pam Adler Gallery
37 West 57th Street
New York, NY 10019

Betsy Rosenfield Gallery
226 East Ontario
Chicago, IL 60611

Carl Solway Gallery
314 West 4th Street
Cincinnati, OH 45202

*C.T. Chew*

A.W.D.
1807 North 90th Avenue
Seattle, WA 98103

*Judy Cooke*

Blackfish Gallery
325 Northwest 6th Avenue
Portland, OR 97209

Foster/White Gallery
311½ Occidental Avenue South
Seattle, WA 98104

*Dennis Evans*

Linda Farris Gallery
322 2nd Avenue South
Seattle, WA 98104

*Gaylen C. Hansen*

Monique Knowlton Gallery
153 Mercer Street
New York, NY 10012

*Randy Hayes*

Linda Farris Gallery
322 2nd Avenue South
Seattle, WA 98104

*Paul Heald*

Traver Sutton Gallery
2219 4th Avenue
Seattle, WA 98121

The Fountain Gallery
117 Northwest 21st Avenue
Portland, OR 97209

*Robert Helm*

Robert Helm
Route 1, Box 654
Pullman, WA 99163

L.A. Louver Gallery
77 Market Street
Venice, CA 90219

Hans Redmann Gallery
1000 Berlin 15
Fasanenstrasse 30
West Berlin, Germany

*William Hoppe*

Richard Hines Gallery
2030 5th Avenue
Seattle, WA 98121

*Paul Horiuchi*

Woodside Braseth Gallery
1101 Howell Street
Seattle, WA 98101

*William Ivey*

Woodside Braseth Gallery
1101 Howell Street
Seattle, WA 98101

*Manuel Izquierdo*

The Fountain Gallery
117 Northwest 21st Avenue
Portland, OR 97209

*George Johanson*

The Fountain Gallery
117 Northwest 21st Avenue
Portland, OR 97209

*Fay Jones*

Francine Seders Gallery
6701 Greenwood Avenue North
Seattle, WA 98103

*Diane Katsiaficas*

Traver Sutton Gallery
2219 4th Avenue
Seattle, WA 98121

Space Gallery
6015 Santa Monica Boulevard
Los Angeles, CA 90038

*Mel Katz*

The Fountain Gallery
117 Northwest 21st Avenue
Portland, OR 97209

Linda Farris Gallery
322 2nd Avenue South
Seattle, WA 98104

*Andrew Keating*

Linda Farris Gallery
322 2nd Avenue South
Seattle, WA 98104

Ellen Sragrow
80 5th Avenue
New York, NY 10011

*Lee Kelly*

The Fountain Gallery
117 Northwest 21st Avenue
Portland, OR 97209

Hodges/Banks Gallery
319 1st Avenue South
Seattle, WA 98104

*Edward Kienholz and
Nancy Reddin Kienholz*

Elisabeth Kubler
Gallery Maeght
Predigerplatz 10–12
8025 Zurich, Switzerland

*Sheila Klein*

Sheila Klein
2625 First Avenue
Seattle, WA 98121

*Jacob Lawrence*

Terry Dintenfass
50 West 57th Street
New York, NY 10028

Francine Seders Gallery
6701 Greenwood Avenue North
Seattle, WA 98103

*Norman Lundin*

Francine Seders Gallery
6701 Greenwood Avenue North
Seattle, WA 98103

Allan Stone Gallery
48 East 86th Street
New York, NY 10028

Space Gallery
6015 Santa Monica Boulevard
Los Angeles, CA 90038

Harris Gallery
1100 Bisconnet
Houston, TX 77005

Allport Associates Gallery
1000 Magnolia Avenue
Larkspur, CA 94939

*Robert Maki*

Robert Maki
8 Florentia Street
Seattle, WA 98109

*Sherry Markovitz*

Linda Farris Gallery
322 2nd Avenue South
Seattle, WA 98104

*Alden Mason*

Diane Gilson Gallery
209 Occidental Avenue South
Seattle, WA 98104

Charles Cowles Gallery
420 West Broadway
New York, NY 10012

Tortue Gallery
2917 Santa Monica Boulevard
Santa Monica, CA 90404

*Peter Millett*

Linda Farris Gallery
322 2nd Avenue South
Seattle, WA 98104

Grapestake Gallery
2876 California Street
San Francisco, CA 94115

*Tom Morandi*

The Fountain Gallery
117 Northwest 21st Avenue
Portland, OR 97209

*Carl Morris*

The Fountain Gallery
117 Northwest 21st Avenue
Portland, OR 97209

Woodside Braseth Gallery
1101 Howell Street
Seattle, WA 98101

Kraushaar Galleries
724 5th Avenue
New York, NY 10019

Triangle Gallery
95 Minna Street
San Francisco, CA 94105

*Hilda Morris*

The Fountain Gallery
117 Northwest 21st Avenue
Portland, OR 97209

Woodside Braseth Gallery
1101 Howell Street
Seattle, WA 98101

Triangle Gallery
95 Minna Street
San Francisco, CA 94105

*Frank Sumio Okada*

Woodside Braseth Gallery
1101 Howell Street
Seattle, WA 98101

*Lucinda Parker*

The Fountain Gallery
117 Northwest 21st Avenue
Portland, OR 97209

Hodges/Banks Gallery
319 1st Avenue South
Seattle, WA 98104

Suellen Haber Gallery
133 Greene Street
New York, NY 10012

*Mary Ann Peters*

Linda Farris Gallery
322 2nd Avenue South
Seattle, WA 98104

*Jack Portland*

The Fountain Gallery
117 Northwest 21st Avenue
Portland, OR 97209

Hodges/Banks Gallery
319 1st Avenue South
Seattle, WA 98104

Gallery Paule Anglim
14 Geary Street
San Francisco, CA 94111

Eason Gallery
388 East DeVargas
Santa Fe, NM 87501

*Michele Russo*

The Fountain Gallery
117 Northwest 21st Avenue
Portland, OR 97209

*Norie Sato*

Linda Farris Gallery
322 2nd Avenue South
Seattle, WA 98104

*Buster Simpson*

Buster Simpson
P.O. Box 21091
Seattle, WA 98111

*Michael Spafford*

Francine Seders Gallery
6701 Greenwood Avenue North
Seattle, WA 98103

*Peter Teneau*

Peter Teneau
2374 Northwest Lovejoy Street
Portland, OR 97210

*Margaret Tomkins*

Diane Gilson Gallery
209 Occidental Avenue South
Seattle, WA 98104

*George Tsutakawa*

Foster/White Gallery
311½ Occidental Avenue South
Seattle, WA 98104

Contempory Sculpture Center
3-10-19 Ginza
Chuo-ku, Tokyo

*Patti Warashina*

Foster/White Gallery
311½ Occidental Avenue South
Seattle, WA 98104

Theo Portnoy Gallery
56 West 57th Avenue
New York, NY 10019

was designed by Howard Jacobsen
of Triad, Fairfax, California.
The text type is Galliard,
set at Type by Design, Fairfax.
The title display is Berkeley Oldstyle.

Production assistants were
Michael Fennelly, design,
Sara Schrom, typography, and
Mark Shepard, mechanical production.

Color separations, duotones,
printing, and binding were executed by
Dai Nippon Printing Co., Ltd.,
Tokyo, Japan.

Printed in 5 colors on
100-pound TopKote stock.